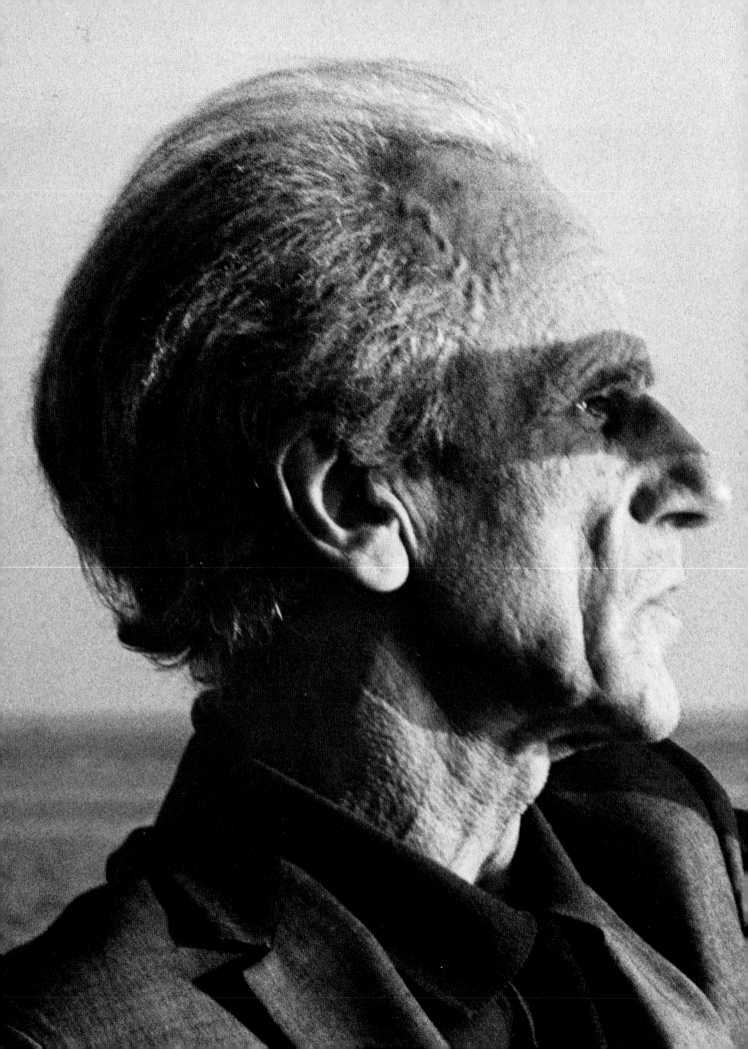

JOSEPH CORNELL

by Diane Waldman

George Braziller New York

Copyright © 1977 by Diane Waldman
Copyright © 1977 by the Estate of Joseph Cornell for Pls. 13,
16, 18, 21, 42, 49–53, 56, 58, 60, 61, 63, 75, 98
Published simultaneously in Canada by McGraw-Hill Ryerson
Limited

For information address the publisher:
George Braziller, Inc., One Park Avenue, New York, N.Y. 10016

Library of Congress Cataloging in Publication Data
Waldman, Diane.
 Joseph Cornell.
 Bibliography: p.
 1. Cornell, Joseph. I. Cornell, Joseph.
N6537.C66W34 709'.2'4 76–16446
ISBN 0–8076–0833–5
ISBN 0–8076–0834–3 pbk.

Designed by Roberta Savage
Printed in the U.S.A. by The Press of A. Colish, Mount Vernon, N.Y.
First Edition

Photographic Credits

References are to Plates unless specified "Fig." for text figures.

Franco Aschieri, Turin (66, 67, 70, 73); Oliver Baker Associates, Inc., courtesy National Collection of Fine Arts, Smithsonian Institution, Washington, D.C. (46); E. Irving Blomstrann, Hartford (55); Will Brown, Philadelphia (Fig. 25); Geoffrey Clements, New York (31, 68); Geoffrey Clements, courtesy Whitney Museum of American Art, New York (34); Mary Donlon, New York (Fig. 5); Mary Donlon and Robert Mates, courtesy Solomon R. Guggenheim Museum, New York (35–37, 39); Eeva-Inkeri, New York (88); Tom Gower, Minneapolis (69); The Solomon R. Guggenheim Museum, New York (20, 94, 99, Figs. 10, 14, 19, 21–23, 28); Robert Hanson, New York (32); Bruce C. Jones, courtesy Xavier Fourcade, Inc., New York (15, 23, 33, 47, 48, 71, 72); Robert E. Mates, New York (10, 38, 40, 78, 100); Robert Mates and Gail Stern (11, 12); Katherine McHale, Chicago (1, 19, 22, 24, 26, 29, 30, 54, 74, 77, 89); Museum of Contemporary Art, Chicago (28, 57, 59, 80, 96); Museum of Modern Art, New York (Figs. 15b, 17); National Collection of Fine Arts, Smithsonian Institution, Washington, D.C. (65, 97); Eric Pollitzer, New York (41, 42, 49–53); Eric Pollitzer, courtesy Castelli/Corcoran/Feigen, New York (2, 4–6, 8, 9, 13, 16–18, 21, 56, 58, 60–63, 75, 98); Nathan Rabin, New York (84); Schambach und Pottkämper, Krefeld, courtesy Solomon R. Guggenheim Museum, New York (Fig. 8); John D. Schiff, courtesy Solomon R. Guggenheim Museum, New York (76); Patricia Stewart, Chicago (87); Soichi Sunami, New York (81, Fig. 18); Frank J. Thomas, Los Angeles (Fig. 12); Frank J. Thomas, courtesy Castelli/Corcoran/Feigen, New York (7).

Half-title: Joseph Cornell's signature, from the back of *Space Object Box*, late 1950s. Solomon R. Guggenheim Museum, New York.
Frontispiece: Joseph Cornell in Westhampton, Long Island, September 29, 1971 (photograph by Hans Namuth).

CONTENTS

Acknowledgments 6

Introduction 7

Plates (color) 33

Plates (black and white) 73

Notes 115

List of Plates 116

Bibliography 120

Acknowledgments

I would like to express my gratitude first and foremost to the family of Joseph Cornell, especially to his sisters Elizabeth Benton and Helen Jagger, and to his niece Helen Batcheller, whose advice and assistance proved invaluable. I am indebted to Sandra Leonard Starr and to Castelli/Corcoran/Feigen, publishers of the *Joseph Cornell Portfolio*, for providing catalogue information on Cornell's works as well as the bibliography on which mine is based; and to Constance Leila Rogers and Clair Zamoiski for compiling additional documentation. I very much appreciate the assistance of Carol Fuerstein, who aided me in the initial stages of editing the manuscript, and James Hoekema, whose insightful editorial criticism was responsible for the final version.

Many thanks are due to both public and private collectors for their generous cooperation, to the dealers Leo Castelli, Richard L. Feigen, James Corcoran, and Xavier Fourcade for providing photographs and documentation, and to Betsy Richebourg of the Castelli Gallery for general assistance. Lynda Hartigan was most helpful in providing information and advice about several unpublished early works. I would also thank Roberta Savage, who is responsible for the design of this publication, and George Braziller, without whose support and encouragement this project could not have been realized.

Finally, of course, I am indebted to the late Joseph Cornell, with whom I had the pleasure of working closely from 1963 to 1967, and who remained a friend until his death in 1972. To his memory I dedicate this book.

INTRODUCTION

His "crystal cages," guardians of clear, urgent dreams, are made in the image of a solitary man who would like to be unapproachable and yet is tormented by a desire to communicate with his fellow men. Between his hands, small worlds spring up unceasingly, full of reality and life.[1]

When Joseph Cornell died at the age of sixty-nine on December 29, 1972, he was almost unknown outside the loose circle of artists and poets, curators and critics, dealers and collectors that constitute the New York art world. Originally associated with the Surrealist painters and poets during the 1930s, Cornell appeared peripheral to the New York School that dominated American art during the late 1940s and 1950s, as he seemed left behind by the relentless advances of the avant-garde during much of the 1960s and early 1970s. Today, however, in a climate which acknowledges a diversity of styles that would have been unthinkable a decade ago, Cornell has achieved a new prominence, and his true stature as a major American artist is only now becoming fully appreciated by a larger public.

Cornell's unique life and extraordinary personality make him an elusive and continually fascinating figure. A shy and reticent man to the art world, to his family and friends he was full of flashes of ironic wit and humor. Often described as a recluse, he constantly received visitors and made gifts of his boxes and collages, and his letters almost always included an image or clipping of special, if enigmatic, significance. Cornell thrived on the excitement of Manhattan, yet he lived out his entire adult life in a simple frame house on Utopia Parkway in Queens. While he never attended college or art school, and never traveled to Europe, his works are filled with recondite references to obscure figures of the European past—especially those of the nineteenth-century Romantic Ballet. As if by design, Cornell's life of relative obscurity followed by posthumous fame seems to recapture an image of the artist that belongs not to this century but to the Romantic era of Cornell's dreams and fantasies.

Cornell's art gives full expression to his enigmatic personality. His principal contribution—and the central focus of this study—lies in the development of his "shadow boxes," small-scale box constructions in which pasted papers, reproductions, sand, pipes, and other found objects are assembled in a kind of collage with depth, framed in wood, and usually sealed with glass. Cornell produced a great number of these boxes, many of them undated, as well as numerous variations on individual boxes and virtual repetitions of a single theme in more than one work. The themes of Cornell's box constructions also reappear in the other forms and media in which he worked: collages, film, a published scenario, several complete issues of *Dance Index* magazine (essays in the field of the Romantic Ballet of a hundred years ago), articles published in the important Surrealist publication, *View* magazine. Besides these, there are the accumulations of materials that Cornell called *Explorations*, containing notations, clippings, photographs, engravings, and three-dimensional objects. The distillation of all of these interests into the spare but poetic fantasy of his boxes has transformed the box construction into a realm of both precise and enigmatic existence.

Descended from an old Dutch New York family, Joseph I. Cornell was born in Nyack, New York, on Christmas eve, 1903. The sixth of that name in his family, he grew up in a large comfortable house together with his two sisters, Elizabeth and Helen, and a brother Robert. His maternal grandfather was William Voorhis, inventor of the steam catamaran, whose brother John had been a well-known New York politician. The Cornell family lived in several houses in Nyack, the last one at 137 South Broadway, at the corner of Voorhis Avenue (named after the family). Cornell's father was a textile designer and salesman for George E. Kunhardt, a manufacturer of fine textiles. Ill for six years with leukemia, he died on April 29, 1917, when Cornell was thirteen. A good-humored man with a taste for luxurious goods, he left no will and died terribly in debt. The next year, shortly before the Armistice, the family moved to a smaller house in Douglaston, Long Island.

With the aid of his father's employer, Cornell was able to attend the Phillips Academy at Andover, Massachusetts, from 1917 to 1921. He earned some money by waiting on tables and, according to his sister Elizabeth, worked for at least one summer in Kunhardt's textile mill in Lawrence, Massachusetts. At Andover he developed his collector's taste for early American Sandwich glass. He also went out for track. The headmaster at Andover told his mother that Joseph was a very unusual child suffering from great insecurity: he noted that, in typical schoolboy fashion,

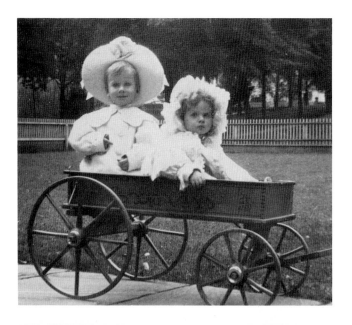

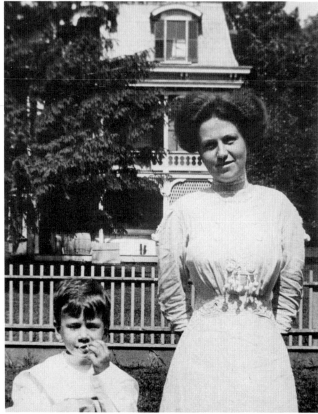

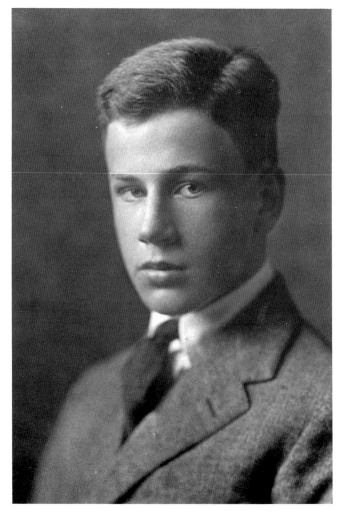

1. Cornell and his sister Elizabeth.
2. Cornell and his mother, Helen S. Cornell, c. 1909, at Voorhis Avenue and South Broadway, Nyack, New York.

3. Cornell's photograph superimposed over that of his father.
4. Cornell as a student at the Phillips Academy, Andover, Mass., c. 1921.

Cornell had pinned up posters on the walls of his room; one morning he discovered the posters in shreds on the floor. Although beset by more than the usual number of nervous crises, Cornell proved a diligent student. Once, at home for Christmas during school recess, Cornell confided in his sister Elizabeth that he had studied astronomy at school and was frightened by the concept of infinity. He took the equivalent of two years of high school French, but he received no formal training in art, music, or French literature—avid interests that Cornell cultivated only after leaving school. This taste for French literature and art developed into a lifelong passion for Symbolist painters such as Odilon Redon and the poets Charles Baudelaire and Stéphane Mallarmé, assuming particular importance as Cornell developed his own poetic metaphors in his work. Admiring and identifying with the solitary sensibilities of Edgar Allen Poe and Charles Lamb, Cornell also read such Protestant mystics as Jakob Boehme and John Woolman, and valued the work of Wordsworth, Emily Dickinson, and Novalis.

Suffering as a young man from a serious stomach condition, Cornell was healed by his faith in Christian Science, which he communicated to two members of his family—his brother Robert and his sister Elizabeth; his mother and sister Helen could not accept the practice. Cornell belonged to the Christian Scientist congregations in Great Neck and Bayside and attended noonday meetings at the Fifth Church in New York; it was a faith that was to sustain him through a number of crises and throughout his life.

After little more than a year, the family moved from Douglaston to Bayside, Queens, where they lived in three houses in succession until 1929, when they moved to the modest frame house on Utopia Parkway where Cornell resided until his death in 1972 (Fig. 5). Cornell's mother was able to buy the house with a small inheritance from her grandmother, and she managed to support the four children by taking a number of odd jobs, such as baking and selling cakes, making sweaters that she sold to Abercrombie and Fitch, preparing sandwiches for a local drugstore, and acting as a census taker. In 1921 Cornell went to work as a salesman of woolen goods in the Madison Avenue shop of William Whitman, a friend of his father. During the decade he worked at Whitman's, he managed to scrape up enough money to attend the opera regularly, waiting in line for standing-room-only tickets. Owing to the Depression Cornell lost his job with

Whitman in 1930 and was out of work for several years. His mother, a close friend of Ethel Traphagen, arranged a job for him at the Traphagen studio (not to be confused with the school), where he worked from 1934 to 1940. By 1932, already fully committed to art, Cornell had managed to launch a career in the art world, through which he began to earn a modest income. A few years later, with his mother's approval, he was able to give up working full time and concentrate on art, supplementing his income by a brief stint in a defense plant in 1943 and by free-lancing for magazines from 1940 into the early 1950s.

Cornell was as reluctant to reveal the details of his life as he was to sell one of his works. The house itself, a simple wooden structure painted white with

5. Exterior of the house at 37–08 Utopia Parkway, Flushing, New York, 1976.

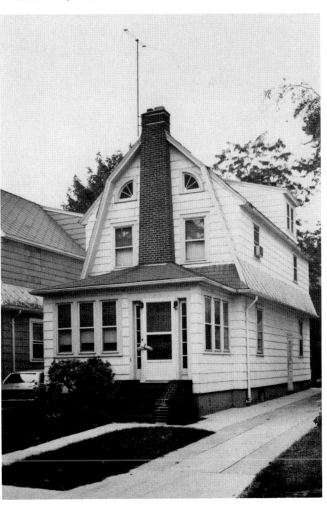

6. Cornell on the beach at Westhampton, Long Island, August 1931.

blue trim, encompassed the daily life of the Cornell family as well as Cornell's working space. An enclosed sun porch led to a room reserved for his invalid brother Robert, an amateur radio operator whose sophisticated electronic equipment enabled him to communicate with people all over the world. Cornell was very attached to his brother and often incorporated Robert's charming drawings into his own work. The house was full of books, archives, memorabilia, most of it collected by Cornell on his endless forays into New York City. Gradually his creations took over more and more of the house, especially after his two sisters married and moved away. Attic, garage (Fig. 7), dining room, basement—the latter his official "studio" —were cluttered with work, some finished, some in progress. Notwithstanding the cramped quarters and normal family tensions, Cornell always insisted that

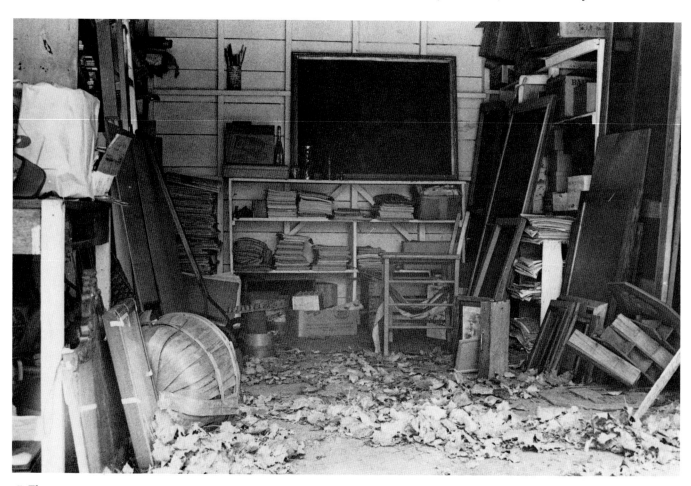

7. The garage at 37–08 Utopia Parkway (photograph by Harry Roseman).

his art was the result of a loving and understanding milieu, without which it would have been impossible for him to function productively. He would recall Sunday afternoons, after church, listening to Protestant services on the radio, and the great sense of religion that infused the wonderful warmth of his family life.

During the 1920s Cornell became immersed in the life and culture of New York, absorbing classical music and modern French art, going to the theater and frequenting Oriental shops between 25th and 32nd streets, where he found Japanese prints and the first small boxes for his objects. Cornell often spoke of the boxes as having been fashioned out of a great love of the city—of a place and a time, with its seemingly endless plethora of books and material. He haunted the old Fourth Avenue bookshops looking for first editions and purchasing hundreds of books, many of which he cut up for their illustrations. He frequented the Metropolitan Museum, the Public Library Picture Collection, and the Bettman Archives, making photographic copies of his favorite images. The essence of his experiences and adventures—his forays into the city—have been captured in his boxes and given to us, in wave after wave of memories, with a pulsating sense of life. The boxes and collages were his progeny. They engaged in a dialogue with him and with each other over the years as, indeed, they speak to us.

With no formal schooling in art, most of Cornell's training during the early 1930s was largely the result of the lively artistic climate that existed in New York. The scene, while admittedly lively, was also confined, and for lack of a meeting place (The Club, a New York gathering place for artists, poets, and critics, was not formed until 1943), many of the New York and expatriate European artists would frequent the few avant-garde galleries then in existence. It was at the Julien Levy Gallery, which opened in 1931, that Cornell met most of the painters and writers associated with the Surrealist movement who were in the United States prior to and during World War II. The first American exhibition of Salvador Dali took place there in 1933. The next year, for his second exhibition, Dali arrived in New York to much acclaim, followed shortly thereafter by other leading Surrealists.

Soon after Cornell saw Max Ernst's collage-novel, *La Femme 100 têtes* of 1929 (Fig. 8), he showed his own initial efforts at collage to Julien Levy (Plates 41, 42). These consisted of montages on cardboard, done in

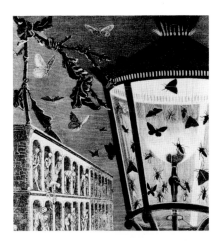

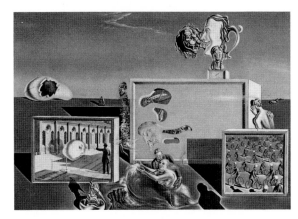

8. Max Ernst. *And the Butterflies Began to Sing.* 1929. From the collage novel, *La Femme 100 têtes.* Private collection.

9. Salvador Dali. *Illumined Pleasures.* 1929. Museum of Modern Art, New York, Sidney and Harriet Janis Collection.

10. Max Ernst. *Here Everything Is Still Floating.* 1920. Executed in collaboration with Jean Arp. Museum of Modern Art, New York.

the photocollage technique pioneered by Ernst, which Levy included in the now historic Surrealist group show held in January 1932. Cornell also designed the cover of the catalogue for this exhibition, which launched the movement in New York. The exhibition included collages by Ernst, paintings by Dali, Ernst, Picasso, Man Ray, Pierre Roy and others, and photographs by Eugène Atget, J. A. Boiffard, Man Ray, George Platt Lynes, and László Moholy-Nagy. Dali's *The Persistence of Memory* (1931) was a highlight of the show for Cornell, and the meticulous technique of this painting—as well as Dali's incorporation of box configurations in a work such as *Illumined Pleasures* (Fig. 9)—no doubt influenced Cornell's later development. Cornell himself exhibited a glass bell containing a mannequin's hand holding a collage of roses. The glass bell, of course, was a common Victorian decorative object used for displaying clocks, artificial flowers, or other *bibelots*; the mannequin's hand was a standard prop of the Surrealists. Man Ray exhibited his *Snowball*, a commercial souvenir in the shape of a glass globe. In 1926, he had altered two such souvenirs, replacing the standard Eiffel Tower or Sacré-Coeur with a tiny reproduction of a Picasso still life in one instance and a porcelain eye in the other. The objects, which could be viewed through their miniature snow storms, undoubtedly influenced Cornell's frequent use of glass bells in the thirties.

In the fall of 1932, Julian Levy held an exhibition of Cornell's "Minutiae, Glass Bells, Coups d'Oeil, Jouets Surréalistes."[2] Cornell's shadow boxes were small, the largest measuring 5 by 9 inches. They were complemented by thimbles propped on needles; bisque angels and minuscule silver balls placed under small glass bells; and bright colored sequins, sewing pins, cut-up engravings of fish and butterflies, colored sand, and brass springs—all moving freely about in small round boxes resembling compass cases. Both the objects and their containers varied little from their original state; they were "transformed," in the manner of Marcel Duchamp and the style of the period, with only slight alterations to the "found" object. All of Cornell's creations of this period (for example, Pl. 46) have several features in common: they are diminutive, fragile, and modest in ambition, yet they have a particular charm and distinctive individuality that sets them apart from the work of his more advanced fellow Surrealists. Even

at this early stage in his development Cornell's proclivities both identify him with and isolate him from doctrinaire Surrealism. Lautréamont's famous passage adopted by the Surrealists as their leitmotif, "Beautiful as the chance meeting of a sewing machine and an umbrella on a dissecting table,"[3] is echoed by Cornell in one of his earliest works (Pl. 42). Yet while utilizing the Surrealist technique of disorientation through seemingly random juxtapositions (Pl. 51, compare Fig. 10), Cornell's collages of the early 1930s also reveal a disarming innocence and naiveté quite different from the black humor and disturbing, often grotesque effects deliberately cultivated in Surrealist painting and poetry.

Linked with the Surrealists for many years, Cornell neither subscribed to the group's tenets nor participated in their activities. Although he rejected the label, Cornell took great pains to stress the importance of the movement and cited individual members as a major source of inspiration and support (Pl. 99). The stimulation provided by their mere presence during the formative years of his career was as invaluable to him as it was to so many younger artists then at work in New York. Like the paintings of his peers who formed what has variously been called the school of Action Painting or Abstract Expressionism, now more commonly known simply as the New York School, Cornell's art did not develop from Surrealism alone but was the end product of the vast input of twentieth-century abstraction. Ultimately, of course, his work, like theirs, succeeded as a unique and personal entity. Yet in order to comprehend fully his innovation as well as his relationship to the movement that was the primary catalyst for his work, it is necessary to discuss Surrealism in some depth.

The movement was officially launched in Paris in 1924 with the publication of André Breton's *Manifesto of Surrealism*. The brilliant group of painters and poets who rallied to the Surrealist banner under Breton's energetic leadership included several members of the Dada movement—among them its creator, Tristan Tzara, as well as Max Ernst, Jean Arp, and Man Ray. The general spirit of Dada, especially its antirational character and its exhibitionism, became a basic part of Surrealism. Like the Dadaists before them, the Surrealists exploited the bizarre, the irrational, the accidental, in an outright assault on the formal and rational order of Cubism, which

they felt to be a major barrier to the subconscious. The spontaneity of the earlier movement, however, was quickly organized into a doctrinaire program by Breton. Whereas Dada had been basically an art of protest aimed at the destruction of the existing political, social and esthetic system inherited from World War I, Surrealism proclaimed a constructive mission in the belief that its doctrines could structure a new order for art and society. Convinced that the unconscious was the essential source of art and life, the Surrealists set out to explore the hidden recesses of the mind. The first issue of the official organ of the Surrealists, *La Révolution Surréaliste*, edited by Pierre Naville and Benjamin Péret, appeared in 1924, proclaiming the importance of the dream. René Crevel, in the Surrealist essay, "L'Esprit contre la raison," wrote:

Is it not for the mind a truly magnificent and almost unhoped for victory, to possess this new liberty, this leaping of the imagination, triumphant over reality, over relative values, smashing the bars of reason's cage, and bird that it is, obedient to the voice of the wind, detach itself from the earth to soar higher, farther O, wonderful responsibility of poets. In the canvas wall they have pierced the window of Mallarmé's dream. With one thrust of the fist they pushed back the horizon and there in the midst of space have just discovered an Island. We touch this Island with our finger.[4]

Breton also believed in the ultimate unification of two seemingly contradictory states, the dream and reality, into one reality: "surreality."[5] It was in fact Apollinaire, a major source of inspiration to both Dadaists and Surrealists, who in 1917 had coined the term "surreal" to describe man's ability to create the unnatural.[6] The Surrealists were opposed not to reality as such, but to reason and logic. To rid the mind of preconceived ideas, to free words (and later objects) from the cliché-ridden contexts to which they had been relegated for so long, to renovate poetic imagery, the Surrealist poets employed the illogical association of words—always surprising and often shocking.

The Surrealists believed that the function of the poet or artist was to communicate the immaculate primary concept (the moment of intuition), not by describing it, but by selecting the appropriate word or image as symbol, which would act as stimulus or

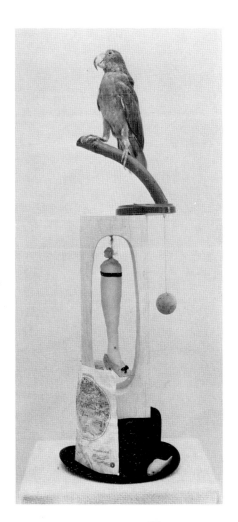

11. Joan Miro. *Object* (sculpture). 1936. Museum of Modern Art, New York, gift of Mr. and Mrs. Pierre Matisse.
12. Kurt Schwitters. *Lust Murder Box II*. c. 1920. Norton Simon Museum of Art, Pasadena.

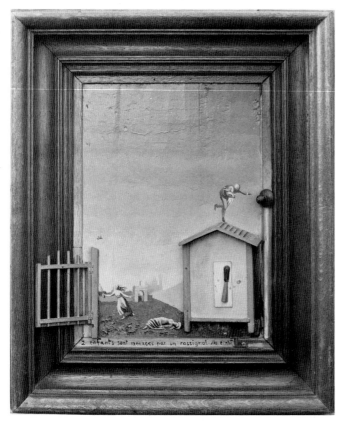

13. Marcel Duchamp. *Boîte-en-valise* (*Box-in-a-Valise*). 1941. Museum of Modern Art, New York, James Thrall Soby Fund.

14. Max Ernst. *Two Children Are Threatened by a Nightingale.* 1924. Museum of Modern Art, New York.

irritant to the senses of the spectator. This in turn would arouse multiple images and emotions, differing according to the sensibility of each viewer (corresponding to the power and magic of the myths, parables, and metaphors of the past).

The estrangement of the object, particularly its separation from the objects generally associated with it and from any form of narrative, became the basic technique of Surrealism. Objects that formerly belonged to separate planes—both spatial and conceptual—were placed in unexpected juxtaposition. Paul Nougé speaks of the Surrealist as painting the "bewildering object and the accidental encounter . . . by isolating the object . . . breaking off its ties with the rest of the world We may cut off a hand and place it on the table or we may paint the image of a cut-off hand on the wall."[7]

Collage and construction were the principal media for this juxtaposition of unrelated images and objects. By extension, the work of art itself came to be treated as an irrational, isolated "object" (Fig. 11). It was in this context that Schwitters (Fig. 12) and Duchamp—especially with his portable museum, the *Boîte-en-valise* (Fig. 13)—experimented with the box as a type of object whose detailed and often intricate construction belied an underlying absence of "rational" function. Cornell's major innovation was to combine the associate urgency of the estranged object with the impacting formal power of the box. Starting where Ernst had left off in the transition from collage to construction (Fig. 14), Cornell made of the box construction a unique means of plastic expression—a vivid, memorable realm of both real and imagined existence.

In 1936 Cornell was included in a major exhibition, "Fantastic Art, Dada, Surrealism," at the Museum of Modern Art. His *Soap Bubble Set* of that year (Fig. 15a) is reproduced in the catalogue as a "Composition of objects, $15\frac{1}{2} \times 14\frac{1}{8}''$, photographed with additional effects by George Platt Lynes." In the form in which it appeared in the exhibition (Fig. 15b), it was acquired by the Wadsworth Atheneum in 1938 (Pl. 55). In the final version each of the objects is located both within its own compartment and in fixed relationship to the others—an early attempt to group separate objects into a coherent unit with a new sense of three-dimensional form, scale, and structure. To achieve this Cornell was forced, temporarily at least, to abandon the random movement of objects in the earlier constructions.

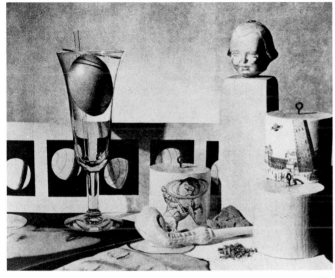

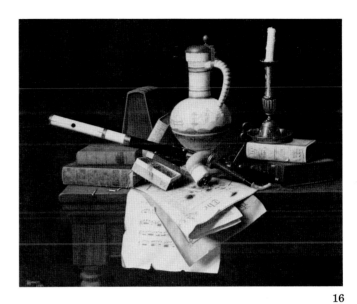

15a

16

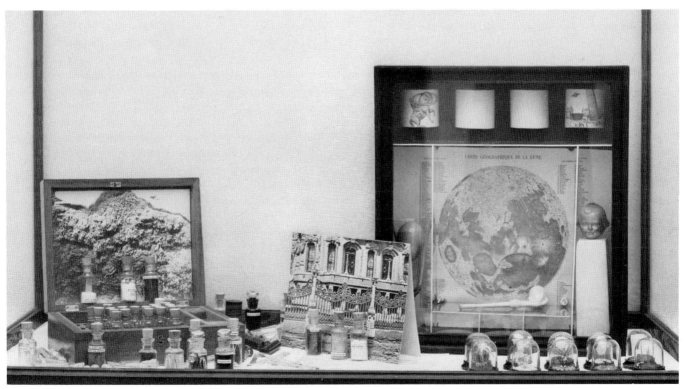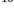

15b

15a. Joseph Cornell. *Soap Bubble Set.* 1936 ("photographed with additional effects by George Platt Lynes," from the catalogue of the exhibition "Fantastic Art, Dada, Surrealism").

15b. Joseph Cornell. *Soap Bubble Set.* 1936. Installation view (rear right), including other objects by Cornell, at the exhibi-

tion "Fantastic Art, Dada, Surrealism," December 1936–January 1937, Museum of Modern Art, New York.

16. William Harnett. *Emblems of Peace.* 1890. Museum of Fine Arts, Springfield, Massachusetts.

Symbols which recur throughout his work appear for the first time: clay pipes (associated with memories of lower New York, Chambers Street and old houses near the water), glasses, engravings, mirrors, maps. The objects lend themselves to a fairly plausible interpretation: the egg as the symbol of life; the glass, the cradle of life; the four cylinders, his family; and the doll's head, himself. The moon, placed above the clay pipe, is both soap bubble and world, and it controls the tides. In the catalogue for a later exhibition, held at the Copley Galleries in California in 1948, Cornell wrote about the theme of the Soap Bubble Sets:

Shadow boxes become poetic theatres or settings wherein are metamorphosed the elements of a childhood pastime. The fragile, shimmering globules become the shimmering but more enduring planets—a connotation of moon and tides—the association of water less subtle, as when driftwood pieces make up a proscenium to set off the dazzling white of sea-foam and billowy cloud crystallized in a pipe of fancy.[8]

In the same catalogue, Cornell is listed as an American Surrealist, a label both accurate and inadequate —and by the late 1940s clearly obsolete. Unlike the Surrealists, Cornell did not feel compelled to break all ties with the past. If one compares the *Soap Bubble Set* with, for example, William Harnett's *Emblems of Peace* (Fig. 16), one can observe the importance to Cornell of the American nineteenth-century *trompe-l'oeil* painting tradition. Both Harnett and Cornell show us the tactile world of material things, Harnett by recreating objects with print and painted facsimiles, Cornell by presenting us with the objects—albeit usually slightly altered—themselves. Where the two artists differ is in meaning, Harnett concerned with the illusion of the real, Cornell with the depiction of the incongruous, the mysterious realm beyond reality. The theme suggested by Harnett's title reduces the element of enigma created by his juxtaposition of objects; Cornell's title is a clue but to only one of many possible interpretations. In this respect, Cornell's arrangement of objects is closer to that of another artist, the French Surrealist, Pierre Roy, whose paintings of glasses, eggs, and clay pipes were shown in the same Museum of Modern Art exhibition of 1936 that included Cornell's own modest contribution. In a very special sense, Cornell was able to fill a substantial gap between the pragmatic aspects of American realism and the metaphysical tendencies inherent in Surrealism.

Cornell was also indebted to a major precursor of Surrealism, Giorgio de Chirico. In *The Mystery and Melancholy of a Street* of 1914 (Fig. 17), distant perspective and strong cast shadows create an illusion of isolation and silence, of stillness and remote nostalgia. Like Cornell, De Chirico creates a sense of time stopped, a vacuum in which sparse objects pause, shedding their known identities for new ones that must be guessed. The series of *Metaphysical Interiors* (for example, Fig. 18), begun by De Chirico around 1915, contains stacks of carpenters' rules, T-squares, geographical maps, biscuits, and candies placed in tightly sealed rooms in which one can occasionally glimpse windows or portholes. The hermetic space of

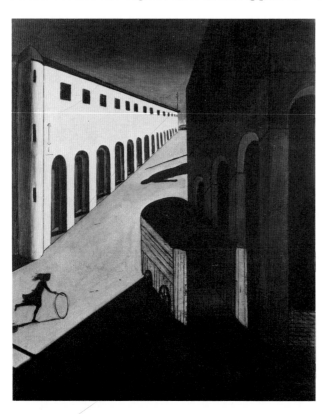

17. Giorgio de Chirico. *The Mystery and Melancholy of a Street.* 1914. Collection Mr. and Mrs. Stanley R. Resor, New Canaan, Connecticut.

these interiors is paralleled in many of Cornell's early boxes (for example, Pl. 11).

In any comparison of the work of De Chirico and Cornell, the name of Max Ernst must figure prominently. De Chirico's metaphysical landscapes of 1914–18, depicting the empty vistas of the great square of Turin, are reflected in Ernst's painting *Aquis Submersis* and his lithographs *Fiat Modes pereat ars,* both of 1919. Cornell, encapsulating both De Chirico and Ernst, produced his own variation, a collage of 1933 (Pl. 49). The spatial distortion and the use of mannequins in the Ernst lithograph from the *Fiat Modes* series, *Let There Be Fashion, Down with Art* (Fig. 19), derived from De Chirico, have been transformed even further by Cornell in his juxtaposition of three-dimensional figures with a number of diagrammatic rays in the form of cones. Just as De Chirico had offered Ernst a way out of Dada, so De Chirico and Ernst provided Cornell with the means of sidestepping the literalism that became the bane of Surrealism. This seminal work of 1933 reveals the juxtaposition of two- and three-dimensional images in an ambiguous spatial context that became the characteristic formal device in Cornell's later collages of the 1950s and 1960s (Pl. 40).

The influence of film techniques on Cornell's art, and the incorporation of cinematic devices into certain of his constructions, originated in the twenties when he, like the Surrealists, found that film offered new possibilities of fantasy and illusion, abrupt changes in time, sequence, and event, and illogical juxtapositions. Cornell made several movies, beginning with *Rose Hobart,* which was collaged from *East of Borneo* (Columbia Pictures, 1931) and named after its star. It was first shown at the Julien Levy Gallery in 1937 as part of a program of "Goofy Newsreels." *Cotillion,* collaged from old Hollywood movies, documentaries, and "Little Rascals" films, formed part of a trilogy (with *The Children's Party* and *The Midnight Party*) begun in the thirties and completed in 1968 by Larry Jordan according to Cornell's instructions. All are cinematic paraphrases of the Duchampian concept of the Readymade, in the sense that the images are pre-existing, altered not by the hand of the artist but by the decision-making process of his mind and imagination.

The nostalgia evident in these films, however, is clearly not Duchampian. Cornell's version of the altered Readymade served a larger humanistic con-

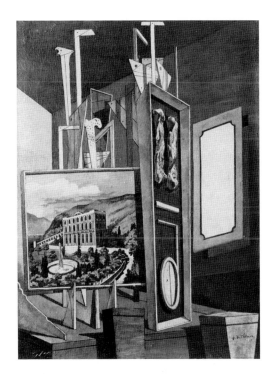

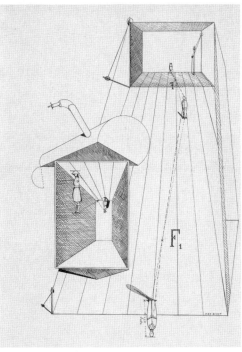

18. Giorgio de Chirico. *Grand Metaphysical Interior.* 1917. Museum of Modern Art, New York, gift of James Thrall Soby.
19. Max Ernst. *Let There Be Fashion, Down with Art.* 1919. From a portfolio of 9 lithographs, *Fiat Modes pereat ars.* Museum of Modern Art, New York.

cern, as can be seen in a later film, *Gnir Rednow,* made from Stan Brakhage's *Wonder Ring* of 1955: a series of images of the Third Avenue El before it was torn down. Cornell reversed Brakhage's film, printing it backwards and adding at the end the title: "The End Is the Beginning." Cornell saw the process of life encapsulated in the El's transition from a shiny new feat of engineering, as a landmark of New York City, to its final phase of decay and dissolution. In addition, the El recalled poignant memories of great importance to him. From the train windows he caught glimpses of faces or fragments of life in the tenements facing the El. Some of these images began to obsess and stimulate him, becoming the core from which he would build outward and eventually resolve them into a construction. Or, as he expressed in conversation, these flashes of recognition would bring into focus an unrelated image already in the process of formation.

Cornell wrote two movie scenarios, one of which, "Monsieur Phot," appeared in Julien Levy's book *Surrealism* (1936). The script, written in 1933 (there were four copies, all handmade), calls for props which have as vivid an existence as the characters, including a basket of laundry, a large mirror, an equestrian statue, and a Victorian horse-car. The plot takes place in winter 1870, New York City, and revolves around a photographer in formal dress, a group of urchins, an eccentric pianist, and a maid with a feather duster. The action shifts abruptly from scene to scene. Chandeliers jangling like Japanese wind bells are reflected in the large mirror—this reflection becomes the chandeliers in the interior of a "large, sumptuous glass and china establishment," a "forest of exquisite glass and ceramics"[9] through which a pheasant of gorgeous plumage flies as if through the "branches of his native wood."[10] Suddenly, in a dream scene of considerable symbolic significance, revolver shots ring out, shattering the glass into a million crystal fragments. The power of this sequence stems from the recurring play of glass, mirror, reflections, crystals—all images of Surrealist origin especially reminiscent of Breton:

In Madame de Richochet's salon
The mirrors are beads of crushed dew
The console is made of an arm plunged into ivy
And the carpet dies like waves.[11]

Much of this imagery, including that of the epilogue

to the scenario in which the pheasant is seen again under a glass bell, is used repeatedly in Cornell's assemblages of the 1930s. The suggestions of action, especially the sequences involving the pheasant and revolver shots, coalesce in a construction of 1939, *Black Hunter* (Pl. 3), one of Cornell's earliest experiments with movement.

The first exhibition of Cornell's work to receive some notice in the press opened on December 6, 1939. The press release states that his objects "derive from a pure subconscious poetry unmixed with any attempt to shock or surprise. They are essentially pure creation, no professionalism, no ulterior motive but the concrete expression of Cornell's personal lyricism. They are useless for any purpose except to delight the eye and everyone's desire for a loveable object...." *Art News* of December 23, 1939, commented: "Much, if not all, is done with mirrors ... and the reflections which do not have the aid of quicksilver are images drawn from the unconscious." The objects were placed in a darkened room; they included "bubble pipes, thimbles and china dolls showered with confetti, in and out of shadow boxes... birds, books and balls suspended on strings, and its strange alchemy of bottles, artificial green leaves and bits of broken glass." *The New York Times* of December 10, 1939, mentioned a "... whirling eyeball under a bell jar, or a book which is a box in which things slide and kaleidoscope...." At least one object, like a music box, played tunes. The *New York Herald Tribune* of December 10, 1939, treated the show as a "holiday toy shop of art for sophisticated enjoyment, and intriguing as well as amusing."

In addition to the pieces on exhibit, Cornell built objects to order, for Christmas gifts, incorporating the photograph of the purchaser into the object. Approximately 5 inches high, 6 inches wide, and 1 inch deep, these "daguerreotypes," forerunners of the later Sand Trays, featured the photo, tinted deep blue or brown, secured against the rear wall of the box. Placed over the photo but not touching it was a tinted mirror which Cornell cut to silhouette the form in the photograph. Between these two layers, particles of colored sand, slivers of glass, and tiny seashells created ever-changing patterns as the box was manipulated. The image of the spectator, trapped in the mirror's reflection, became a part of the object, establishing at an early date Cornell's awareness of the physical presence of the spectator, the

relationship between the spectator, the object, and the space between.

If much of the thirties was a time of tentative beginnings, the next decade witnessed a number of major constructions. Characteristic of the early 1940s is a feeling for Victoriana—for quaint beauties, elegant fabrics, and exotic papers—a recapitulation of the sentimental "objects" of the thirties. Often, the subject is classified only by the nondescriptive term "Object" (Pl. 7), even though a brief legend clearly establishes the mood of the piece; other works are accompanied by a lengthy inscription, descriptive matter (Pl. 9), or some other "leitmotif;" more rarely such "documents" become an integral, rather than additive, part of the form itself (Pl. 58). Cornell seems to have become obsessed with annotation in an effort to capture every fleeting moment. The constructions themselves vary considerably. Some, like *Paolo and Francesca* (Pl. 6), resemble his earlier flat collages assembled in depth. Others are table-top, horizontal boxes, often lidded, suggesting a jewel box, a sewing box, a cosmetic case, a place to store treasures, a Pandora's box; *L'Égypte de Mlle Cléo de Mérode cours élémentaire d'histoire naturelle,* 1940 (Pl. 9), is a typical example. The interior, with rows of bottles and side compartments, recalls the display cases of a museum or department store.

The box, a Victorian writing or strongbox of dark-stained oak, contains a piece of glass mounted about one and one-half inches from the bottom which acts as a supporting rack for the bottles. Underneath the glass is a layer of red sand with a few broken bits of things (a small piece of comb, slivers of plain and frosted glass, and a porcelain doll's hand and arm broken at the elbow). The upper half of the inside of the box, most of the inner cover, the rack for holding the bottles, the shelves along the sides, and the corks of the bottles are covered with an ivory paper delicately marbled in brown and Prussian blue. The bands of the inside of the top, framing the large field and the inside of the sides of the lid, are covered with a marbled paper of Prussian blue, blue-gray, ivory, and orange spots (the colors are listed in declining order of dominance).

The following is a description of some of the glass bottles and their contents:

"Sauterelles" contains a reproduction of two camels and Bedouins from an old photo of one of the Pyra-mids, a small green ball, both set in yellow sand. The part of the cork inside the bottle is painted black. (*Sauterelles* = grasshoppers, locusts.)

"Nilomètre" contains a one-inch section of a blood-sample tube, with a bulb, in a little green liquid. (*Nilomètre* = an instrument to measure the height of the Nile's waters, especially during the flood.)

"Cléopatride/Cadeau d'émeraudes de Cléo de Mérode:" bottle is full of cabochon rhinestones (from a necklace) behind pale blue film paper.

"Gameh, Kontah/Blé (triticum sativum, Linn)" contains about a hundred pieces of string, each about one inch long, dipped in yellow paint, with small clusters of gold dust on one end. (*Blé* = wheat.)

"CLÉO DE MÉRODE/sphynx:" set in yellow sand is a cut-out bust-length photo of a woman with hair parted in the middle and pulled back into a loose bun. She wears a choker and a dress with a revealingly low neckline and puffed sleeves.

"Pétrifications animales/albâtre de Cléopâtre" contains a frosted glass cup handle, a biscuit porcelain cup handle, and a pierced fragment of bone.

"Colonnes tournoyantes" contains a needle impaling a small red wood disk labeled, on the side, "Cleopatra's needle." The double thread from the eye of the needle is wound around the bottom of the bottle. A pin is buried in the cork stopper.

Cléo de Mérode was a famous personality of the 1890s. The most beautiful belle of *La Belle Époque,* she was an aristocrat by birth, a ballerina by profession, and linked romantically with King Leopold II, the aging bon-vivant of Belgium. For Cornell she was the muse of this box. The goddess Hathor, pictured on the inside lid, is the goddess of love, happiness, dancing, and music, also goddess of the sky. Cléo in the title is also Cleopatra of Egypt. The composition of the box relates to Egyptian burial practices, to the custom of securing in the tomb the articles most required by the deceased in his life after death, as well as a description of his life on earth. It suggests, as well, the registers into which the narrative wall reliefs of the tombs are structured. Simultaneously, the objects offer clues to the essence and mystery of Woman, whether Cléo de Mérode or Cleopatra.

Cornell's passion for the ballet continued unabated throughout his career. In individual announcements, in specific works, and in his designs for *Dance Index* he acknowledged his devotion, often becoming friendly with some of the more famous ballerinas of his time. This was especially true of Zizi Jeanmaire, who was the subject of one of his boxes, a whimsical adaptation of his "lobster ballet" (Pl. 8), and who was rumored to have been the inspiration for his Aviary series. Fantasy or fact, he did present his interpretation of the Romantic Ballet, a display entitled *La Lanterne Magique du Ballet Romantique,* together with decors for "Les Ballets de Paris" choreographed by Roland Petit (Zizi Jeanmaire's husband), at the Hugo Gallery in the 1940s. Later in the 1950s, such dancers as Allegra Kent became identified with paintings of the Renaissance. Images taken from Parmagianino, for example, were used as surrogate forms just as other figures from Renaissance pictures became stand-ins for Cornell's Medici Prince and Princess.

In several constructions of the 1940s, Cornell's fascination with the Romantic Ballet was expressed explicitly in descriptive texts attached to the boxes. *Taglioni's Jewel Casket* of 1940 (Pl. 64), in the collection of the Museum of Modern Art, New York, is labeled with the following anecdote:

On a moonlight night in the winter of 1835 the carriage of Marie Taglioni was halted by a Russian highwayman, and that enchanting creature commanded to dance for this audience of one upon a panther's skin spread over the snow beneath the stars. From this actuality arose the legend that to keep alive the memory of this adventure so precious to her, Taglioni formed the habit of placing a piece of artificial ice in her jewel casket or dressing table, where, melting among the sparkling stones, there was evoked a hint of the atmosphere of the starlit heavens over the ice-covered landscape.

The dark blue velvet which lines the box is the deep night sky. Cornell plays the Duchampian game of chance with the free movement of the glass "ice cubes" he has placed in the construction.

Another work of around 1940, *Mémoires Inédits de Madame la Comtesse de G.* (Pl. 58), is an example of Cornell's use of the round box. (After employing both circular and rectangular shapes during the 1930s, he eliminated the former sometime in the 1940s.) This box, too, captures the spirit of an enchantress, in this instance through the intermediary of her letters, represented by the strips of type placed inside. The interior contains sand—suggesting the passage of time—and a ribbon, which must have tied the letters and thus hints at the intimacies revealed in them. The inside of the box lid appears to be old paper used for lining book covers and looks like a cell structure as seen through a microscope. By implication, these fragments tacitly suggest a diary that could reveal the innermost secrets in the life of *Madame la Comtesse de G.*

Still another biographical construction, rectangular in shape, *Untitled [The Life of Ludwig II of Bavaria],* c. 1941–52 (Pl. 63), contains documents related to the mad prince of Bavaria in juxtaposition with references to his notorious passion for swans and Richard Wagner, along with clippings from the *Christian*

20. Cornell in a photograph by Lee Miller Penrose, 1943–44.

Science Monitor. In format very much like Duchamp's *Boîte-en-valise* (Fig. 13) the contents reveal Cornell's reluctance to divulge himself or subject his art to the type of intellectual scrutiny for which the French artist was famous.

In the *Untitled [Sandbox]* of about 1940 (Pl. 68), shifting sands suggest the movement of waves and the passing of time. The seashells, trapped on the driftwood, evoke the image of a toreador impaled on the horns of a bull. This is one of the few boxes of the period containing an explicit reference to time. The use of the single large piece of driftwood implies the strength of the forces of nature and death; the delicate and fragile seashell attests to the ephemeral quality of life. As stark in its presentation as many of the earlier works are fanciful, this particular work is unique in several respects: in the use of natural, rather than man-made "found objects"—driftwood, sand, and the shells that Cornell was fond of collecting on his long and solitary walks along the beaches of Long Island. These elements coalesce here into a virtually abstract statement, of the type that was to recur in the Sandboxes of the late 1950s. The elongated shape of the box is an unusual feature; although it does recur in certain other boxes of the 1940s (Pl. 70) and in the Sand Fountains, it appears to have been too compressed for the more complicated imagery of Cornell's other work. Perhaps the form of the container was dictated by its contents. It is true that the Sandboxes, even the later works (Pl. 93), have a ruggedness that is often missing from the other constructions.

This unique combination of natural elements, placed in an abstract context, heralds the great inventions that were to follow. It also puts Cornell at a distance from the Surrealists' admiration for the purely cerebral and from what he felt was their distaste for craft—an attitude alien to his own inclinations. This judgment, stemming from Cornell's position as an outsider, was not really accurate, for many of the Surrealists, Max Ernst among them, based a good part of their invention upon actual contact with materials if not upon craft. Rather, Cornell reacted against Duchamp, whose emphasis on the intellect and antipathy to craft he greatly admired but could not follow. Craft, in combination with intuition, became the material for his dreams.

The transition from the many options suggested in the late thirties and early forties to Cornell's first masterpiece, the *Medici Slot Machine* of 1942 (Pl. 11), is both rapid and profound in its implications. The image of the boy, a reproduction of the *Portrait of a Young Noble* then attributed to G. B. Moroni, is viewed as though through a telescopic lens, compressing near and far distances simultaneously. The spiral at the boy's feet evokes multiple associations: in the natural world, ocean currents form a spiral pattern; the growth of many plants is that of a spiral—for example, the way rose petals unfold—as is the structure of a chromosome. Symbolic of time in the form of a clockspring and an allusion to life repeating itself in a cycle of seasons and a cycle of generations, the spiral is also an abstract form, bringing with it references to Duchamp and Leonardo. The complex play of imagery, sequentially strung out (or spliced) like a series of film clips, with the implication of movement both in time and space, reconstructs the history of a Renaissance prince and juxtaposes the images of his imaginary childhood (diagrams of the Palatine fashioned from pieced-together Baedeker maps, etc.), with current objects (marbles and jacks), so that the Renaissance child becomes a contemporary. Certain objects are brought into the present through color, while others, monochromatic, recede into the past. Although Cornell objected to any reference to this process as one derived from film-time sequence, the flashbacks in time together with his obsession with collaging stills from films are cinematic devices that enabled him to encapsulate Renaissance images, silent-film techniques, and commonplace toys into a real and mysterious presence.

In the *Medici Slot Machine*, space is cubistically fragmented into small facets which commingle, separate, and fuse again in kaleidoscopic effect. The black lines that crisscross the surface act as connective tissue organizing both the multiple images and the several spatial levels. This diagrammatic pattern of horizontal and verticals, superimposed on the surface rather than functioning as the substructure for the image, creates a sense of order and calm in keeping with the spirit of the Renaissance subject. The emphasis on the object as a literary symbol, in an earlier work like the *Cléo de Mérode*, gradually gives way to the use of the object as both symbol and form and finds its first realization in the *Medici Slot Machine*.

It would be difficult to imagine a more startling

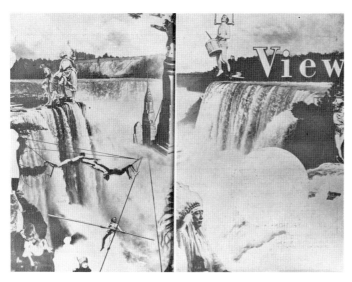

21. Joseph Cornell. "Americana Fantastica." Back and front covers for *View* magazine, January 1943.

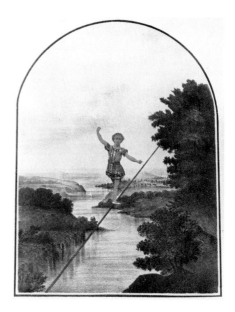

22. Joseph Cornell. "Childhood of Blondin" from the series *The Crystal Cage: Portrait of Berenice, View* magazine, January 1943.
23. Joseph Cornell. Montage from *The Crystal Cage: Portrait of Berenice, View* magazine, January 1943.

contrast to the elusive and even melancholy prince than *A Pantry Ballet (for Jacques Offenbach)* of the same year (Pl. 8) or the later, equally light-hearted *Untitled [Pink Palace]* of c. 1946–48 (Pl. 17), or *La Favorite* of 1948 (Pl. 19). Yet they represent a counter-point to the main body of Cornell's work and play an important, if subsidiary role during the 1940s. Here, references to theater abound, whether to the stage sets of the theater or ballet or to the court pageantry of Watteau. Delicately frivolous in spirit, they also invoke reminiscences of a child's cardboard theater or a fairy tale. Red plastic lobsters cavort gaily about with their partners, little silver spoons, while sea-shells and crockery nod in merry amusement. Else-where, real twigs accompany cardboard cut-outs of pink palaces, and sheet music graces the exterior of a box in which an angel is playing in a world of lyric enchantment.

For *The Crystal Cage: Portrait of Berenice,* pub-lished in *View* magazine in 1943, Cornell created what was to be his major work in collage for some time (Figs. 21–23). Entitled "Americana Fantastica," the issue contained old engravings of scenes from American life and the country's natural and man-made wonders. The most important of the many works by Cornell in this issue was his composite view of Berenice which began with his description of the child:

From newspaper clippings dated 1871 and printed as curiosa we learn of an American child becoming so attached to an abandoned chinoiserie while visiting France that her parents arranged for its removal and establishment in her native New England meadows. In the glistening sphere the little proprietress, reared in a severe atmosphere of scientific research, became enamored of the rarified realms of constellations, balloons, and distant panoramas bathed in light, and

drew upon her background to perform her own experi-ments, miracles of ingenuity and poetry.

Cornell established, through painstaking research undertaken from 1934 to 1942, the existence of the chinoiserie in question, the *Pagode de Chanteloup,* unearthing a "wealth of paraphernalia, charts, photo-graphs, manuscript notes, etc.," relating to this "curious relic of scientific research in the Nineteenth Century."[12] A photograph of the chinoiserie is in-cluded, preceded by an illustration of Cornell's replica of it. He carefully approximates the form of the

pagoda with a pattern of words (in the manner of Dada), placing a picture of Berenice in the doorway. These words refer to his own preoccupations: Mozart, sunbursts, Baedeker, Piero di Cosimo, Hans Christian Andersen, daguerreotypes, balloons, Edgar Allen Poe, shooting stars, Hôtel de l'Ange, soap bubbles, solariums, snow, Gulliver, Carpaccio, phases of the moon, Taglioni ice cubes, starlit fields, palaces of light, tropical plumage, Liszt, barometers, Queen Mab, owls, magic lanterns, aviaries, Milky Way, Vermeer, aerial flights of Carlotta Grisi. Clearly, by this date most of Cornell's vocabulary of themes and images was already formed.

Accompanying the portrait of Berenice is Cornell's interpretation of Émile Blondin, who in 1859 successfully crossed Niagara Falls walking a tightrope (Fig. 22), and a montage of photographs (Fig. 23) for which he gave the following key:

New York City, Central Park, April 14, 1942 (upper left-hand corner); Berenice of the PAGODE DE CHANTELOUP, *ca. 1870 (top center, with stars); to accompany the child Mozart, 1909 (upper right-hand corner); Bérénice rocaille, France, eighteenth century (exact center); La Belle Jardinière, brought from England because of her resemblance to the Mona Lisa to preside over the gardens of Berenice (center left); Berenice, four stars, of the* PAGODE DE CHANTELOUP, *ca. 1875 (bottom center); contemporary print showing preparations of the foundation of the* PAGODE DE CHANTELOUP *(lower left-hand corner). Astronomical tracings from the observatory dome of the pagoda. The pressed flowers are documents, the ribbons from the garments of Berenice shown in the photographs. Bareback-rider, Carlotta Grisi. Survivors of an English life-boat, summer 1942 (lower right-hand corner).*

Cornell usually ignored violence or evil. The *Habitat Group for a Shooting Gallery* (Pl. 10), however, appears to be a comment on war in general and on World War II in particular. On one level, each of the different exotic birds may represent one of the world powers. A bullet hole has shattered the glass. The birds are wounded; behind them on the wall are splashes of vivid color representing blood. Fragments of newspapers and shot-off feathers are at the bottom of the box. The birds (or man), on another level, appear to be innocent victims, trapped by circumstances beyond their control. The bullet hole acts as the unifying factor in the formal composition, tying

the multiple elements together. It controls the direction the eye takes, guiding it clockwise around the surface to the four corners of the box. An illusion of depth, produced by the overlapping of the birds on the printed matter, is denied by the two-dimensionality of the birds themselves. Another box in a similar vein is *Dien Bien Phu* (Pl. 91), occasioned by the French defeat in Indochina, and one of the very few works in which Cornell reacted to a contemporary political or social event. Other examples, unrelated in theme, are works created as memorials, so to speak, to such legendary figures of the 1950s as Marilyn Monroe.

In 1946, Cornell exhibited a number of *Portraits of Women* at the Hugo Gallery in New York—portraits of ballerinas and stage and screen luminaries like Eleanora Duse and Jeanne Eagles. Cornell's comments on his *Penny Arcade for Lauren Bacall* (Pl. 72) are revealing of his art:

... impressions intriguingly diverse—that, in order to hold fast, one might assemble, assort, and arrange into a cabinet—the contraption kind of the amusement resorts with endless ingenuity of effect, worked by coin and plunger, or brightly colored pin-balls—traveling inclined runways—starting in motion compartment after compartment with a symphony of mechanical magic of sight and sound borrowed from the motion picture art—into childhood—into fantasy—through the streets of New York—through tropical skies—etc.— into the receiving trays the balls come to rest releasing prizes ...[13]

Both the *Medici Slot Machine* and the *Soap Bubble Set* of 1936 provided themes that Cornell developed over the years in new constructions that did not differ radically from their original concept. By contrast another type of series—the Aviary, Dovecote, and Hotel boxes, for example—took shape in a relatively short and concentrated time span. Within the first category the progression from a Medici boy of the forties to one of the fifties is documented by the distillation of a rich and elaborate imagery to one of the utmost simplicity. In the second group, the constructions have a greater consistency of expression but vary more substantially from one piece to another. A certain amount of confusion has developed with regard to the serial nature of Cornell's work and has led to a description of this process as one of duplication. As Cornell was at great pains to point out,

however, he did not make facsimiles or reproductions of his work. He did make variations. The idea of repetition is contained in Dada—one need only think of Duchamp's "Readymades" and his acceptance of multiple versions of the same object. Similarly, Arp, in 1918–19, made a practice of tracing the same drawing over and over again with variations occurring automatically. Without surrendering the concept of the Readymade or the found object, Cornell was able to invest his own numerous variations of a theme with all the singularity of the "unique" object.

Cornell's working method offers ample explanation for the necessity of variations on a theme: an initial idea supplemented by "documents"—both original materials and notes—the whole taking visual shape after a long period of gestation. Cornell often spoke of the frustrations of the medium and of his inability to encompass all but a small portion of the extra-visual material (poetic, emotional, etc.—what he termed "ephemera") that went into its making. Variation or elaboration becomes a way of working out an obsession—a natural consequence of the Surrealist belief in taking the inner imagination rather than the outer world as a starting point for invention, and the multitude of possibilities that this suggests. Once brought into existence, the boxes appear to conserve all of this ephemera—how else does one explain the powerful emotional reaction to the most common of objects?—and to establish a familial relationship, through the reiteration of certain objects (driftwood, seashells, cordial glasses, nails, stamps, toy blocks, bubble pipes), and especially photographs and forms—circles, cubes, spirals, and arcs—which take on added reverberations over the years and establish a physical displacement in time.

The implications of the *Medici Slot Machine* are numerous. Not only was Cornell, at this early date, working with a type of serial imagery that became important for other artists, like Andy Warhol, in the 1960s—but he was also resolving the dilemma of rejecting the handmade in favor of the found object by a judicious combination of both. In this process, change becomes as significant a factor as chance. Nowhere is Cornell's homage to Duchamp more evident than in his *Pharmacy* of 1942 (Pl. 66) and 1943 (Pl. 12), an enchanting theme of which there are at least five versions extant. Duchamp's own *Pharmacy*, a "Rectified Readymade" of gouache on a commercial print, was produced in an edition of three in January

1914 in Rouen. The two small red and green marks which constitute Duchamp's alteration of the print, a winter landscape, are his subtle comment on the bottles of colored liquid common in pharmacy windows of that time. Cornell's own construction, a hinged cabinet, features an interior lined with mirrors, creating echoing reflections of apothecary jars which line the shelves. Cork, sand, feathers, dried leaves, labels, copper wire, shells, tinfoil, and tulle are the ephemeral stand-ins for the magical essences of the pharmacist—and a silent tribute to Duchamp's involvement with alchemy. Where they differ substantially is in the end result. Duchamp's *Pharmacy* is an intellectualization of phenomena, Cornell's their tangible transformation.

Cornell's repetition of photostated details of Renaissance portraits, among which the *Young Noble* then attributed to Moroni, Bronzino's *Bia di Cosimo de' Medici,* and Pinturicchio's *A Boy* figure prominently, prefigures Warhol's use of silk-screen images of famous movie stars like Elizabeth Taylor, Marilyn Monroe, and Elvis Presley. Cornell's interpretation of the film still as a repetitive image, with or without variations, can be both poetic and plastic in significance. For Cornell, the repeated image is the starting point for a series of complex developments, for multiple possibilities and associations; for Warhol, the repetition of the image is itself the point, a comment not only upon his subject but on the banality of the very fact of repetition.

The Surrealists gave Cornell a poetic license, as it were, to indulge in a fondness for the esoteric and the commonplace, a taste which should not be confused with the indiscriminate. A great part of the appeal that his work holds today resides in the fact that he declassified the status of the object, and in doing so anticipated not only much of Pop art but Minimal art as well. Although Cornell anticipates what has come to be called the "kitsch" of the sixties, his sense of structure transforms even the most sentimental object into a logical formal entity. During the 1940s, as he gradually began to exclude from his boxes the Surrealist penchant for the anecdotal and the illustrative, eliminating everything but the exact object, texture, color that he sought, the construction itself increased in importance.

As Cornell drew away from Surrealism, the purely formal aspects of Cubism came into play: the flattening out of space, the drastic simplification of forms,

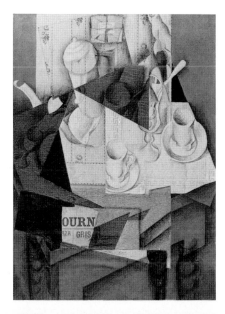

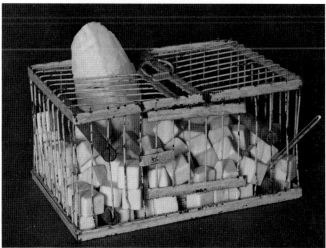

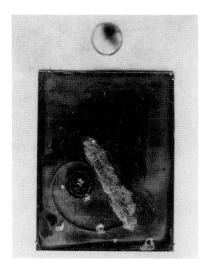

24. Juan Gris. *Breakfast.* 1914. Museum of Modern Art, New York, acquired through the Lillie P. Bliss Bequest.

25. Marcel Duchamp. *Why Not Sneeze Rose Sélavy?* 1921. Philadelphia Museum of Art (Louise and Walter Arensberg Collection).

26. Arthur G. Dove. *Portrait of Alfred Stieglitz.* 1925. Museum of Modern Art, New York.

the rectilinear symmetry of horizontals and verticals, offset by an arc—as in the Cubist collages of Picasso, Braque, and especially Juan Gris (Fig. 24), in whose honor he constructed some of his best boxes (Pl. 88). With the walls of these boxes papered over with collage fragments, the relationship between subject (foreground) and box (background) undergoes a curious inversion. In this respect, they are a reiteration of the ambiguity that exists in Gris's work between the objectlike nature of many of his images and the formal requirements of the abstract ground.

Another alternative existed for Cornell, a way of retaining both structure and image. The *Multiple Cubes* of 1946–48 (Pl. 77) constitutes one of his earliest explorations into pure abstraction, with references to both Mondrian's grid paintings and Duchamp's Readymade, *Why Not Sneeze Rose Sélavy?* of 1921 (Fig. 25). The photographic images of the Medici boxes are metamorphosed into white wooden cubes which move freely about in their separate cubicles, a series of compartments created by a skeleton of horizontal strips bisected by smaller vertical ones. This grid structure, an extension of the reticulated black lines superimposed on the Medici boy, functions in a purely plastic context. The strict formality of the grid, however, is relieved somewhat by the fact that the cubes are not attached to each compartment, thus introducing elements of chance and movement.

In this and related constructions of the fifties, Cornell was undoubtedly aware of the paintings of Piet Mondrian, whose work he saw in New York in the 1940s. Their classic purity, their restriction to white as the predominant color with the primaries blue and yellow as important components, and their breakdown of space all show affinities with Mondrian. Both artists approach geometry through sensibility, but the differences between them are great. Cornell conveys a physical sense of space, in a three-dimensional structure, by overlapping planes and the use of diminishing forms. He loves the irregular surface or edge, the curve, the sphere; he uses natural and man-made forms and representations of the figure. Cornell appears to have intuitively grasped certain essentials of Mondrian's art, adapted them to his own needs, and fused them with his own highly developed poetic imagery. The shallow depth of *Multiple Cubes* tends to flatten out a very real space into a pictorial one. Cornell is a master at the sleight-of-hand, for

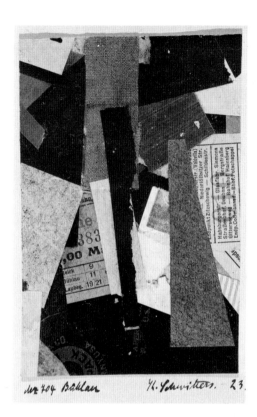

27. Kurt Schwitters. *Merz 704: Bühlau.* 1923. Museum of Modern Art, New York, Katherine S. Dreier Bequest.

Nouveaux Contes de Fées (*Poison Box*) (Pl. 76), of around the same time, reiterates flatness in another context. The pattern of the paper which caresses the surface of the box blurs the distinction between the three-dimensional box and the two-dimensional paper.

In December 1949 Cornell showed twenty-six constructions, based on the Aviary theme, at the Egan Gallery. Continuing the direction of the *Multiple Cubes,* these sunbleached and whitewashed boxes filled with drawers and birds and little springs and mirrors have a strict honesty, a concentration on texture and ordering of space...."[14] The earlier interest in literary detail disappears in favor of an abstract arrangement of forms, a play of line, volume, and shape that is breathtaking in its beauty and simplicity. In these works Cornell moved away from Surrealism much as the Abstract Expressionists did at the same time. From this moment in Cornell's art, the literary becomes subsumed into the abstract.

Both *Deserted Perch* of 1949 (Pl. 78) and *Chocolat Menier* of 1952 (Pl. 84) are notable for their incorpora-

tion of emptiness—the vacuum of an action that has occurred, of birds that have flown from the cage. The mood of loneliness and futility in *Chocolat Menier* is established by the worn and bare wood, the rusting chain supporting the perch, and the slivers of mirror, pitted and chipped away at the edges, waiting to catch the reflection of the spectator and another more jagged mirror. In a less violent mood, a few feathers in the *Deserted Perch* suggest the missing bird. Color is almost nonexistent, kept to small touches in the use of print, string, and feathers. The austerity of these Aviaries is offset by other constructions in which the birds play a lively and colorful role. Similar in mood, if not in subject, is a later construction, *Homage to Blériot* of 1956 (Pl. 34), in which a quivering coiled spring balances on a trapezelike arrangement to suggest the famous flyer, the first to cross the English Channel. By visual implication, at the very least, it is also an homage to Dove's *Portrait of Alfred Stieglitz* (Fig. 26).

Forgotten Game, c. 1949 (Pl. 22), restates the game theme but includes the movement of a ball on a runway accompanied by the sound of its own movement as it descends. Cornell was very early in incorporating sound, light, and movement within the narrow dimensions of his constructions. The geometric simplicity of the precise repetition of the circles is offset by the peeling surface that surrounds it, recalling old walls. Cornell often spoke fondly of buildings in the process of demolition, finding beauty in the fading colors, in the warmth of human association, and in the fragments of decay and destruction. In this he echoes Schwitters; both had a fascination for the found object, using bits of glass, threads, old papers, labels, and other discards (Fig. 27). He also paraphrases Leonardo's example of gazing attentively at a mottled wall and discerning in one patch "... human heads, various animals, a battle, some rocks, the sea, clouds, groves, and a thousand other things ... like the tinkling of the bell which makes one hear what one imagines,"[15] which had enabled Max Ernst to make a clear break with Dada and to renew his interest in natural phenomena. Cornell mirrors both Schwitters and Ernst in his love for the remnants of human use, weathering, and craftsmanship, which, incorporated sparingly into his constructions, cause a single spot or fragment to suggest the universe.

Compared with the Aviary theme, the works of 1950–53 (Observatories, Night Skies, Hotels) are

richer, more sensual and painterly, while retaining the haunting and poetic mood of the bird cages. They have both a clarity of image and a dreamstate of unreality, of atmosphere and emotion. The surfaces are coated with thick white paint. Placed with an impeccable sense of order are glasses, shattered and whole, wire mesh, mirrors, labels of faraway places, and sky charts. Into an aperture cut into the rear wall, Cornell often placed astronomical maps that revolve and change their image, or windows that look out onto star-studded skies. Subtle placements of pilasters, columns, colonnettes, windows, and mirrors convey a shorthand version of deep Renaissance perspective, of the kind one might apprehend from a reproduction of a Renaissance monument rather than from the monument itself.

In the *Central Park Carrousel—1950, In Memoriam* (Pl. 81), a fragment of a sky chart with diagrams of the constellations is placed behind a cylindrical colonnette (actually a sawed-off wooden dowl) and a piece of wire mesh. The images are multiplied by a mirror which gives an illusion of depth to the entire construction. To increase this illusion, Cornell ingeniously reiterated the grids of the constellation in the wire mesh placed in the foreground of the construction. The destruction of the carrousel is implied in the frayed ends of the wire mesh and the sawed-off colonnette. The empty perch, placed in a low position on the right wall of the box, suggests the cage from which the bird has flown. The related movements of the carrousel, the planets, and the bird are patterned by the curve that sweeps from the lower to the upper left. Some time after Cornell had finished this project, he was pleased to discover in *Scientific American* confirmation of his intuition that the flight path of birds does indeed follow the movement of the stars.

In 1950, Cornell showed his Observatory series. In one example (Pl. 80), an aperture in a white interior looks out upon a night sky patterned with stars. Again, the use of wire mesh suggests the bird cage. Cornell conveys the illusion of deep space, a form of *trompe-l'oeil* perspective, by the subtle placement of the colonnette, leading the eye on a diagonal pattern from the column inward to the window and beyond to the limitless expanse of sky. The relationship of this expanse to Renaissance formulations of perspective in both painting and architecture cannot be dismissed as peripheral. The fact that artists in the

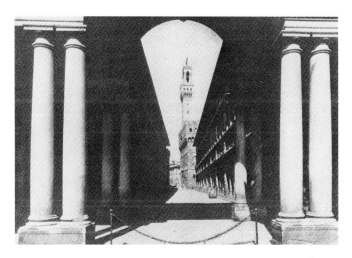

28. Giorgio Vasari. Uffizi, Florence. 1560–74. View toward the Palazzo Vecchio, from *Magazine of Art*, 45:1 (January 1952).

Renaissance were also architects must have been of great interest to Cornell; he probably studied Vasari's diaries and his work on the Uffizi (Fig. 28), Michelangelo's reconstruction of the Campodoglio, and Bernini's great square before St. Peter's, drawing on what he learned from writings and reproductions.

In this enthusiasm for the past, Cornell prefigures Robert Rauschenberg, whom he undoubtedly influenced. Both are fascinated by the rubbish of civilization and reassemble it with an infinite variety of expression. Like Cornell, Rauschenberg rummages through the past, combining it with the present in a rectangular division of space derived from Cubism, with surfaces reworked by an overlay of Abstract Expressionist handwriting. The juxtaposition of the trite and the sophisticated, the illusion of depth and a space-denying, tactile materiality are handled by Rauschenberg in a manner that owes more than a small debt to the work of Cornell. In contrast to Cornell, however, Rauschenberg deals primarily with the subject matter of the present, with the past juxtaposed for ironic comment. Cornell, preoccupied with the past, brings it into the present by formal means. In referring back to the past—whether using a Pinturicchio portrait, rare old books or weathered driftwood, dimestore trinkets or recent issues of *Scientific American*—Cornell orients all of his objects, old or new, toward history—a dream history, the child of his imagination.

Among other major works of the 1950s are *Dovecote* of 1952 (Pl. 85), in which the careful arrangement of open and closed holes suggests movement in space. A severely ordered and abstract box, its formal purity is offset by the element of play common to the earlier Penny Arcade constructions of the 1940s (Pls. 25, 72). Small yellow, blue, and white balls roll around the interior recesses of the box and finally come to rest as they would in an actual game. *Untitled* [*Windows*] (Pl. 79) is one of the purest of Cornell's constructions. It is total enigma; the structure has no literary meaning to speak of other than the fact that the marks on the window panes may refer to actual windows. Its major strength derives from the ruggedness of its construction in which strips of wood are placed in strict rectilinear fashion, forming the surface configuration of the box. Within this network of strips are only the pieces of mirror, the ever-changing images reflected in the glass, and the splashes of paint left by the artist.

The theme for Cornell's show in 1955 at the Stable Gallery was "Winter Night Skies," a series of constructions alluding to the constellations Auriga, Andromeda, and Cameleopardalis. Related in both theme and structure to the earlier Hotels, Night Skies, and Observatories, these works take as their departure an even more painterly approach. The Night Sky series, while connected to such important works as *Pavilion* (Pl. 29), *Observatory* (Pl. 80), and *Carrousel* (Pl. 87), offers another alternative to the interior space of the boxes. In such works as the *Hôtel du Nord,* c. 1953 (Pl. 31), probably named after Marcel Carné's 1938 film of the same name, the three planes of depth generally inferred by the use of columns, wire mesh, sky charts, and windows are considerably reduced if not altogether flattened into a simulation of two-dimensional space. In both the *Hôtel du Nord* and *Night Skies: Auriga* of 1954 (Pl. 89), the column is retained but the impression of depth created by it (and by the aperture in the latter box) is more than offset by the use of devices that call attention to the rear or side walls of the box. In *Night Skies: Auriga,* Cornell inserted the printed legend, "Hotel de l'Etoile"—which he said alluded to the star of the Magi[16]—on both the rear wall and right side of the interior, together with the image of the constellation Auriga, which continues across both surfaces in effect canceling any implication of layered space. In the *Hôtel Bon Port* (*Ann in Memory*) of 1954 (Pl. 30),

he goes one step further, eliminating the column altogether and emphasizing the Cubist device of flattening space by the use of collage elements and fragments of printing. Both *Hôtel du Nord* and *Orion,* 1955 (Pl. 90), with their reemphasis on collage and painterly texture, parallel some of the major developments in the New York School of the fifties.

Over a period of time Cornell made a series of Sand Trays (Pls. 28, 82) and Sand Fountains (Pls. 68, 93). The former usually contain several layers of glass with different colored sands between them. In the sand are bits of seashells, slivers of glass, small ball bearings, and brass or silver rings. As the tray is manipulated, these objects shift about and commingle, appear and disappear, creating everchanging images. The rustling sound of the sand as it moves is like the sound of waves. One *Sand Fountain* of 1956 contains dark blue sand (the sky and the desert), which pours into a wine glass as "an ironic trope on halved Eternity."[17]

Cornell continued to explore his preoccupation with the forces of nature in *Space Object Box* (Pl. 95). The cork ball is symbolic of the sun, the ring is the orbit of the planets around the sun; they are also parts of a game in which the ball can be rolled through the ring. Included in the box are driftwood, a toy block, and an astronomy chart. In discussing his constructions on the theme of space, Cornell has said that he tries to capture in his boxes some of the spirit of the scientific discoveries of our time, and if some humor is caught as well, that is good too.

In 1959, Cornell created several more boxes devoted to actresses; one, *Judy Tyler, in Memoriam,* is dedicated to a young actress who was killed in an auto accident on her way to a television program. Although a memorial, the box is painted white and yellow and contains a smiling sun. A seashell is cradled in a cordial glass. The same mood of innocence and happiness pervades *The Nearest Star* of 1962, dedicated to Marilyn Monroe. The enigma of these boxes can best be expressed in the lines of Valéry:

Midi le juste y compose de feux
La mer, la mer, toujours recommence!
O récompense après une pensée
Qu'un long regard sur le calme des dieux![18]

Cornell stopped making new boxes sometime in the early sixties. After that, as he said numerous times, he worked on "refurbishing" his older boxes, ripping

them apart and partially reconstituting them. The vacuum was, however, more than filled by his renewed interest in collage—beginning, it would seem, in the mid-1950s, at the very time that the boxes began to lose their sense of depth. Such works as the *Hôtel Bon Port* (*Ann in Memory*) of 1954 (Pl. 30) give certain clues as to the direction his work would take in the sixties. Of major significance is the series of boxes executed at this time in homage to Juan Gris (Pl. 88), in which the interior walls of the box become papered over with print, a physical presence that goes a long way toward denying the reality of the box as a construction. In many ways these boxes are about Cubist collage as much as they are a tribute to Gris, for the very use of cut and pasted papers suggests the early collages of Picasso and Braque. Cornell's beloved parrot motif, handled as a real form in what is, after all, tangible space, loses its reality and becomes a dream fragment very much as it would in Cubist collage.

Although Cornell had continued to make collages after the 1930s, he did so intermittently, preoccupied for the most part with the box constructions that constitute the largest part of his production. Collage was used primarily for works that were to be reproduced in print. Not until the 1950s did Cornell turn to collage for the two-dimensional equivalent of his mature box constructions. In these works Cornell substituted an exquisite adjustment of his poetic metaphors to the picture plane for the sense of infinite space conveyed by real objects in the three-dimensional boxes. Although his collages lack the mysterious space of his boxes, they retain the same symbolic connections between images. The fantasy world of his collages, like that of his boxes, exists at the highest level of visual poetry.

Cassiopeia, 1963 (Pl. 35), is a superb example of his later work in collage. The figure to the right—a place usually reserved in his box constructions for a colonnette suggesting infinite depth—has been cut out from a reproduction of Piero della Francesca's *Madonna and Child with Four Angels.* This painting was apparently first reproduced in color on the cover of the December 1957 issue of *Art News,* which also contained an article on Cornell. Obviously taken with the reproduction and the coincidence, Cornell produced this version in which Piero's figure appears virtually intact, "enhanced" only by the addition of two celestial motifs which must refer to the Christ Child as well as the constellation. Other elements— the rabbit and the garish reproduction of a city street—are pure Cornell. As a visual entity, the circular device of the manhole cover, reiterated in the circle created by scoring the surface of the reproduction, successfully fuses the very flattened-out form of the figure and the dimension of depth suggested by the reflections in the street. *Mica Magritte II,* a collage of about 1965 (Pl. 97), acknowledges both his admiration for Magritte and his love for his brother Robert (who died in 1965), whose set of toy trains was very much a part of the Cornell household on Utopia Parkway.

Cornell worked in a tiny basement surrounded by his tools, objects, and obsessions. The room closed in on the visitor like a womb: it was like a larger version of one of his boxes. The artist's workmanship and technique were as impeccable and meticulous as that of an early American craftsman. Every box and all objects placed within a construction were put together in the simplest and most direct way—with screws, nails, pegs, and glue. Although fragile in appearance, the constructions are in reality very sturdy. Most of the early frames were made of wood salvaged from an old Long Island mansion once occupied by a man Cornell knew. In later years Cornell had the boxes made expressly for him but would simply pick up dimestore frames for the collages. All of the frames, however, are as carefully planned as the objects within, for the relationship between frame and object was of utmost importance to Cornell. Often they are rugged in relation to the delicacy of the composition. The frame may add a dimension to the construction: Cornell once said he had chosen a Victorian frame for one of his boxes because it would "take it out of this time...."[19] He often took pleasure in destroying a box and then re-doing it, as he said, "to take up the slack in it." Sometimes he would glimpse the box's perfection in the process of destruction. Cornell altered the original condition of the objects he used: the majority of his surfaces were painted or in other ways reworked. Sometimes he applied eighteen or twenty coats of white paint for density, constantly going over even his finished boxes. He liked to set some of his boxes out in the sun—"to christen them."[20]

He worked on several series at once, each category deriving invariably from a long-meditated and en-

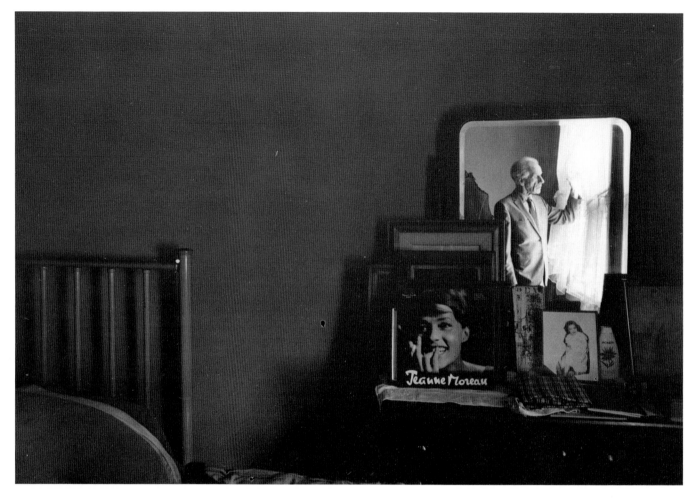

29. Cornell in his bedroom, 1970 (photograph by Duane Michaels).

grossing basic idea. Concerning *Dovecote,* for example, Cornell "talks to his occasional visitors, with a kind of reticent passion, about the many people who kept pigeons thirty years ago, now grown so few that no one even seems to know any longer what a dovecote is. So he has built up a large collection of documents dealing with these abodes and their winged guests: photographs from magazines, postcards, naively symbolic associative images—and from this gestation have resulted several 'boxes' in which white balls roll along strips of wood placed one above the other, in front of circular openings."[21]

In a letter to his sister Elizabeth, dated June 17, 1952, Cornell's notations reveal his extraordinary personality. Entitled "Dog-day jottings," it reads as follows:

Two little wedding cake sugar angels are reposing in separate boxes on dining room table after almost disintegrating in cellar—which reminds us that summer is here at last—although for the last two days we haven't really needed any reminders.

A Sunday-like Victorian parlour restfulness suddenly here after a short jaunt to Flush. Main St.—extra stop-off for shades & saw blade—then library & back to beat the emergency bus situation (see clipping)— heavenly cool and peaceful

had to bring back two shades with the original Harrison & Dally dark green stock—since the war unobtainable from Sweden. its former source & new sub a miserably ambiguous medium green and mealy texture

the Dutch nabiscos that surprised you were the

identical brand that Mother gave hubby for Xmas (last) & which are repeated in part in R's new birthday assortment (yrs. exclus. nabs. will U save box?

(preview from THE CELESTIAL AVIARY*):*
"TURDUS SOLITARIUS, *the Solitary Thrush,*

was formed by Le Monnier in 1776 from the faint stars over the tail-tip of the Hydra, where some modern seeker of fame has since substituted another avian figure, the NOCTUA, *or*
NIGHT OWL.
The title is said to be that of the Solitaire, formerly peculiar to the little island, Rodriguez, in the Indian Ocean, 344 miles to the eastward of Mauritius; although the bird has been extinct for two centuries, as indeed now is the constellation. Little seems to be known of this sky figure, although Ideler wrote of it as Einsiedler, the German Drossel.

(actually, I'd already made a box with this identical winged creature for NIGHT SONGS *show.* THE CELESTIAL AVIARY *is something brand new, however, and just came to me as I copied above out from a fascinating anthology of numerous quotes, allusions, etc. from literature.)*

had already noted that the Ottawa Indians considered the Milky Way as muddy water stirred by a turtle swimming along the bottom of the sky. Which is coming down to earth, remembering skies and turtles of an Indian Summer not too far back.

Cornell managed to combine the objects which delighted him as a child—seashells, butterflies, stamps, toys, marbles, clay pipes—with his obsessions as an adult—ballerinas, empty cages, sky charts, Americana, Charlie Chaplin, Mallarmé, wooden drawers, driftwood, cordial glasses. His objects came from second-hand stores, dimestores, from packages washed up on the beach, from rare books or cheap ones, from science magazines or the *National Geographic;* from anywhere. "Everything can be used, says Cornell—but of course one doesn't know it at the time. How does one know what a certain object will tell another?"[22]

Tenderness and despair, poignancy and loneliness are locked into each compartment, changing within each box and from box to box. Fantasy and architectural constructivism exist side by side in a world

30. Cornell shortly before his death in 1972 (photograph by Rhett Delford Brown).

where knowledge alternates with the innocent wonder of a child. The slightest scrap of paper sets off an endless chain of associations, both emotional and visual, and a paper parrot brings to life a hotel lobby full of sounds and movement, sumptuous wallpaper, and brass cages filled with brilliant birds.

The work of Joseph Cornell brings to mind Gérard de Nerval's statement, of more than a century ago, that art is "the overflowing of the dream into reality."[23] Cornell's dreams, locked within glass-paneled boxes, are deeply personal and ultimately elusive. Mystery is the essence and substance of his work.

PLATES

1. *Snow Maiden.* 1932–33.

2. *Défense d'Afficher.* 1939.

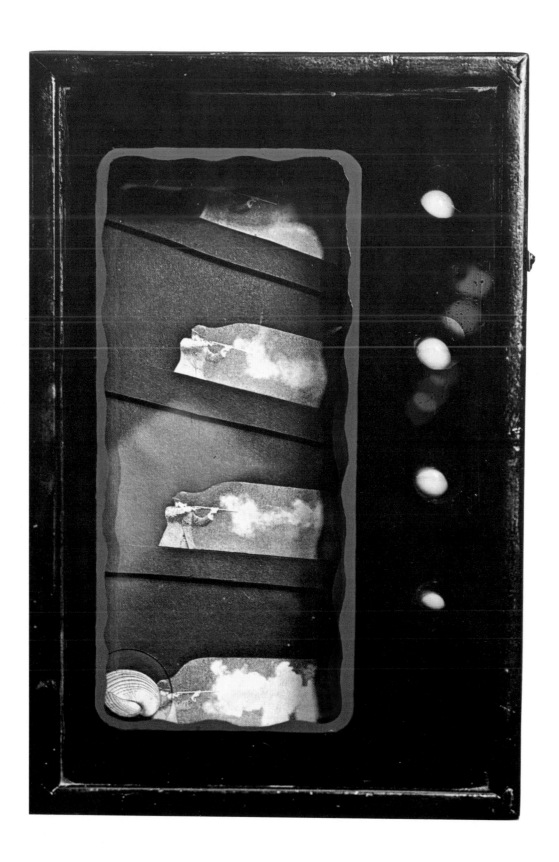

3. *Black Hunter.* 1939.

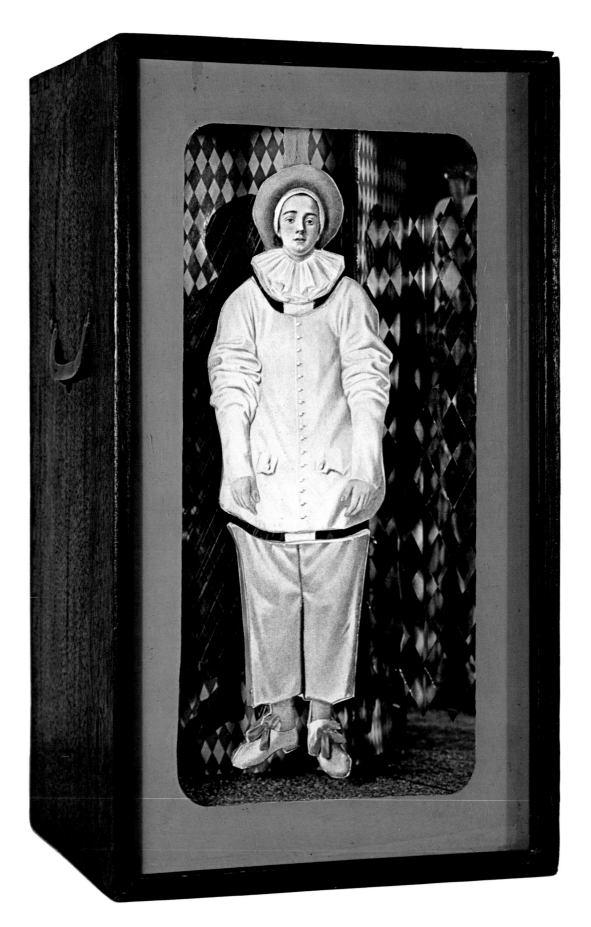

4. *A Dressing Room for Gille.* 1939.

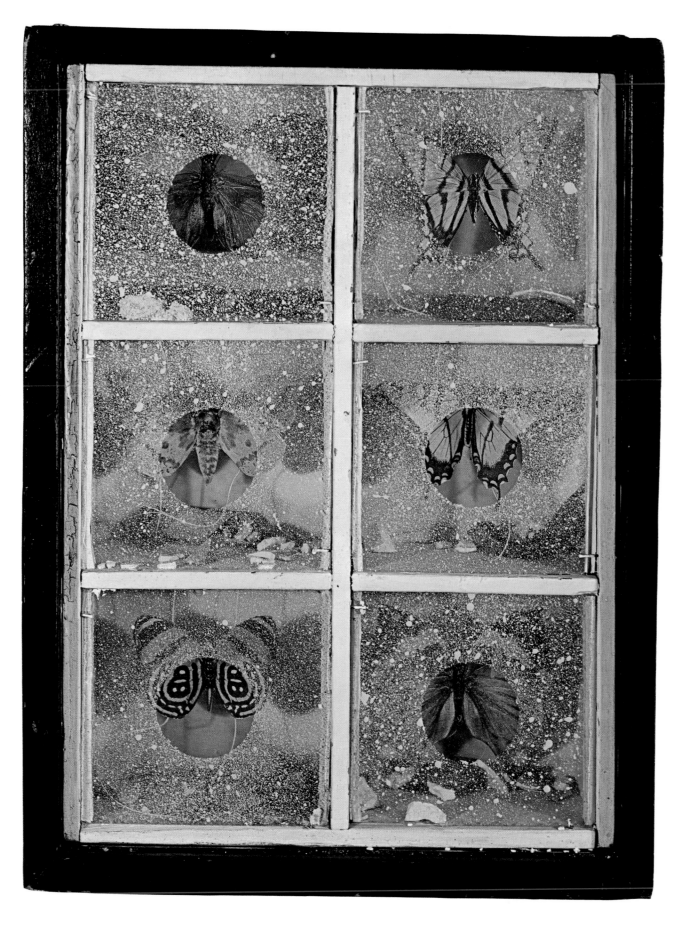

5. *Untitled* [*Butterfly Habitat*]. c. 1940.

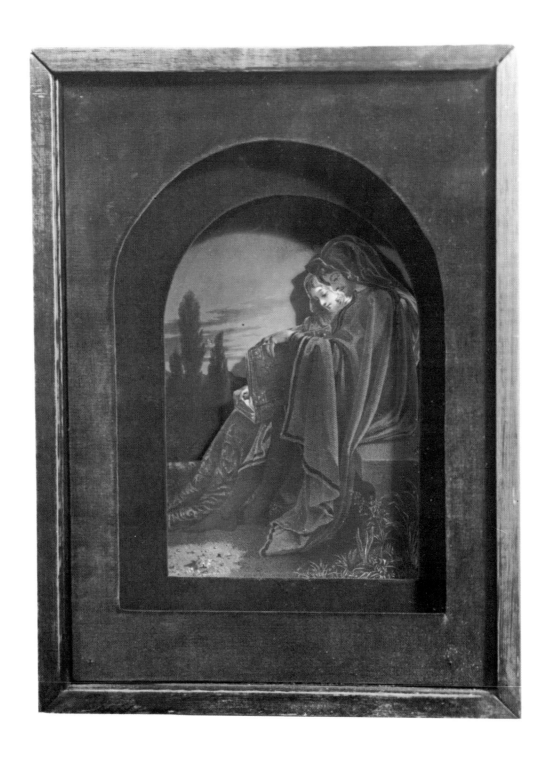

6. *Paolo and Francesca.* 1943–48.

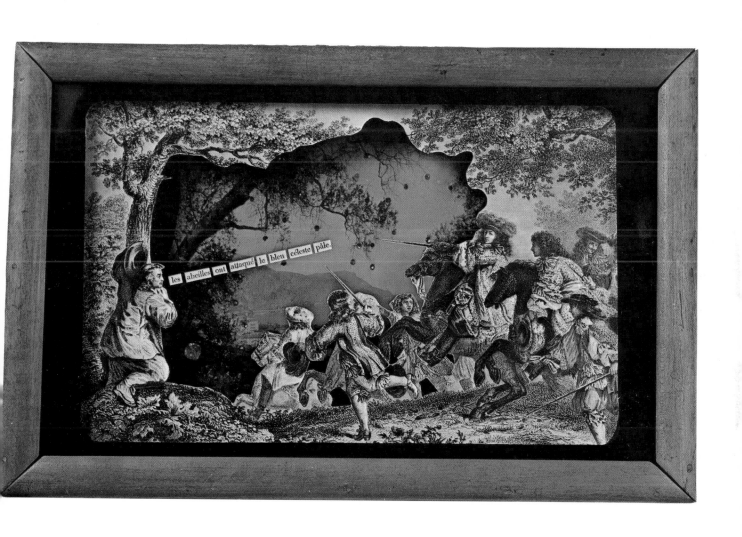

les abeilles ont attaqué le bleu céleste pâle.

7. *Object.* 1940.

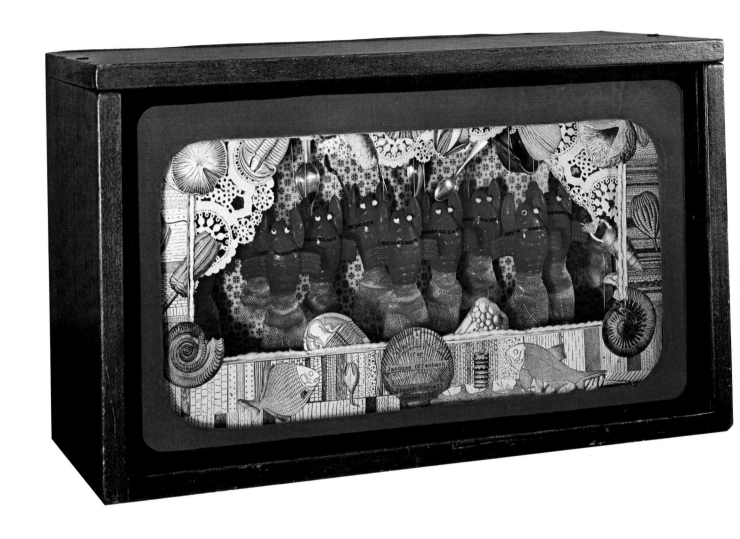

8. *A Pantry Ballet* (*for Jacques Offenbach*). Summer 1942.

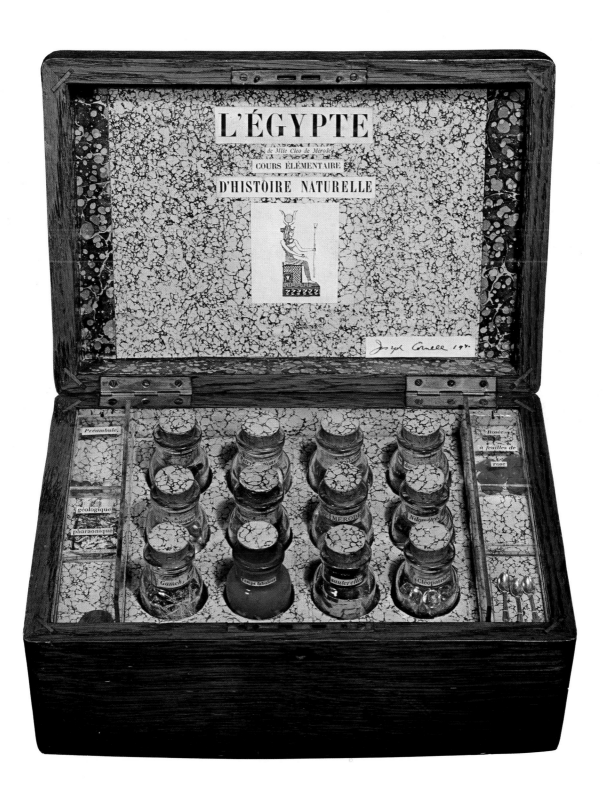

9. *L'Égypte de Mlle Cléo de Mérode cours élémentaire d'histoire naturelle*. 1940.

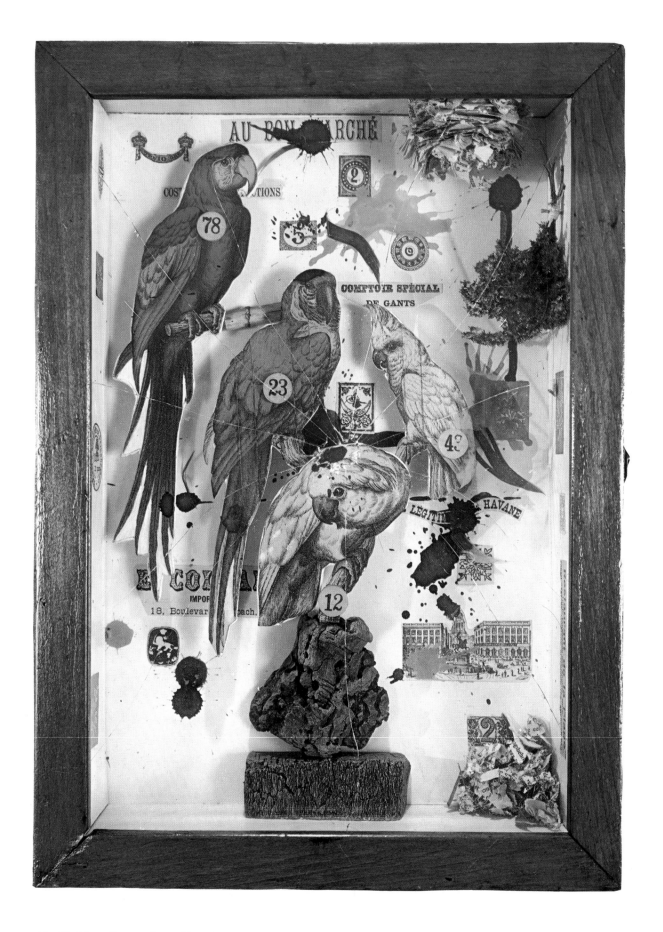

10. *Habitat Group for a Shooting Gallery.* 1943.

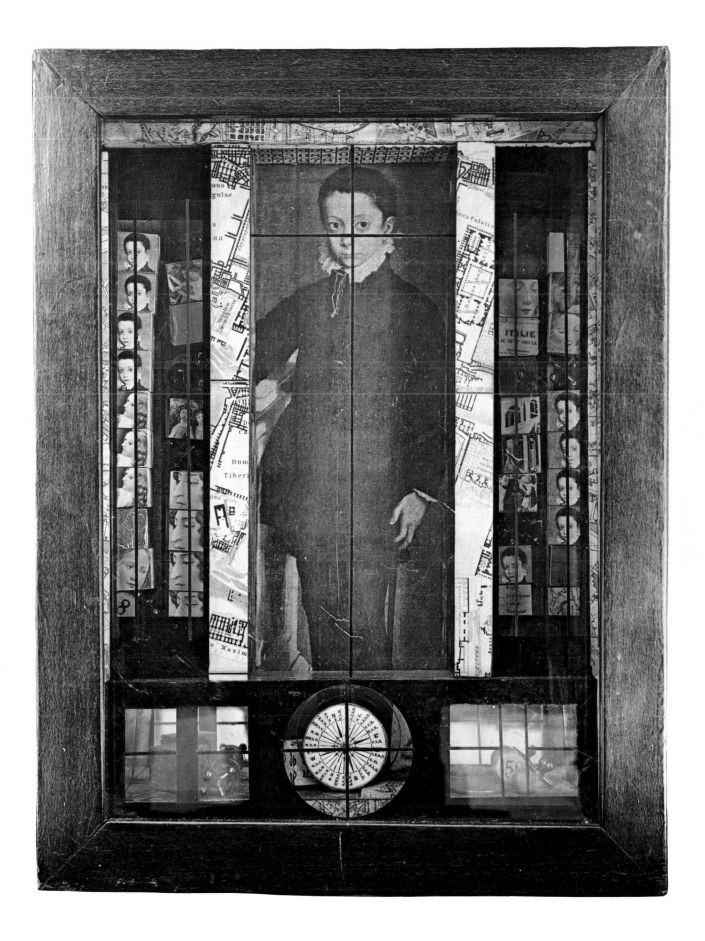

11. *Medici Slot Machine.* 1942.

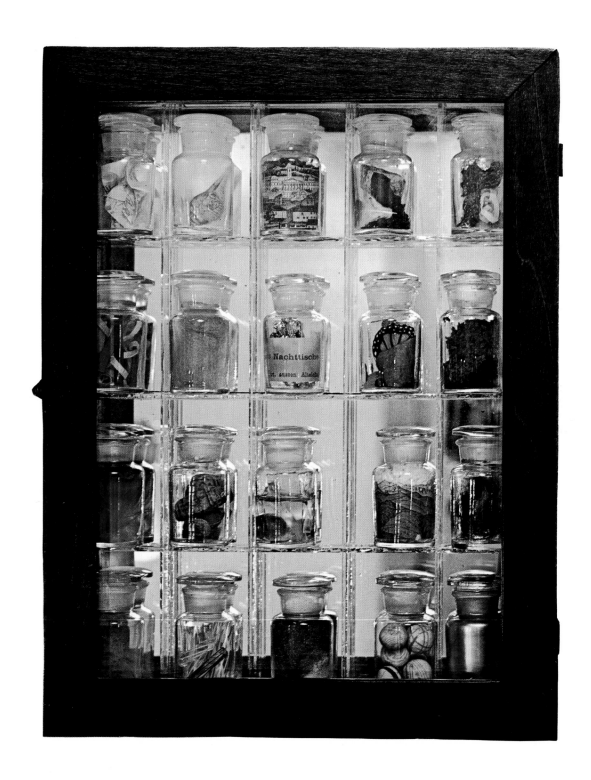

12. *Pharmacy*. 1943.

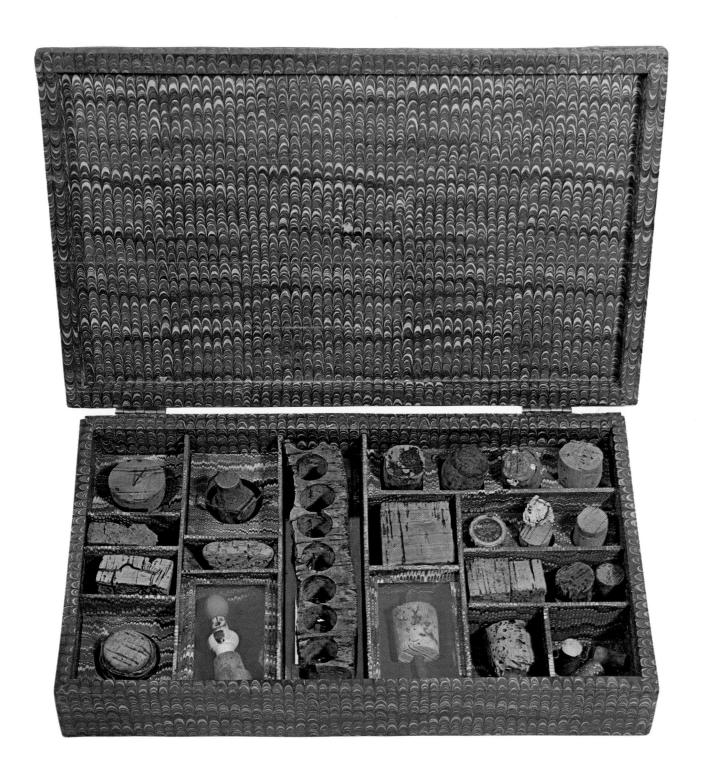

13. *Untitled* [*Cork or Varia Box*]. c. 1943.

14. *American Rabbit.* 1945–46.

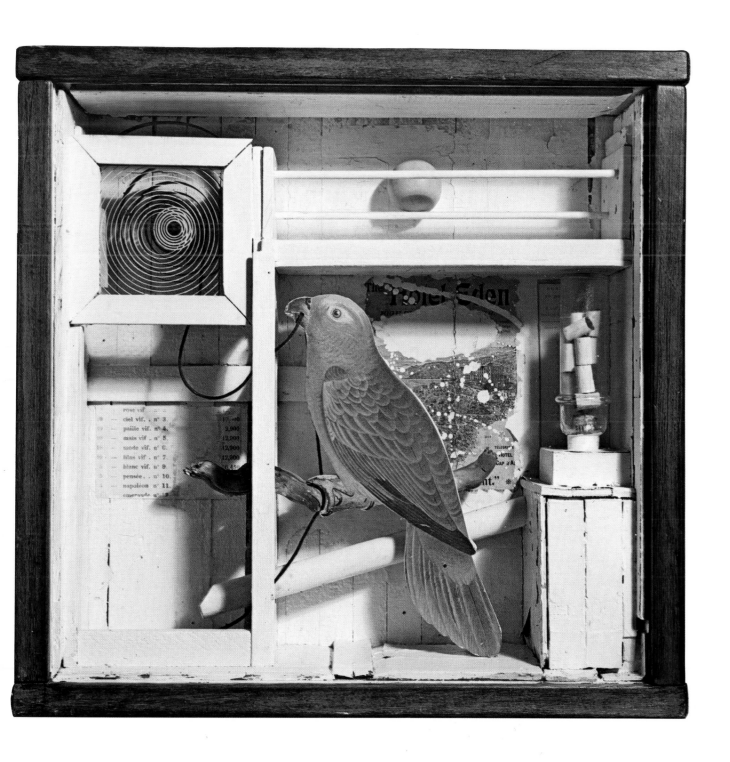

15. *The Hotel Eden.* 1945.

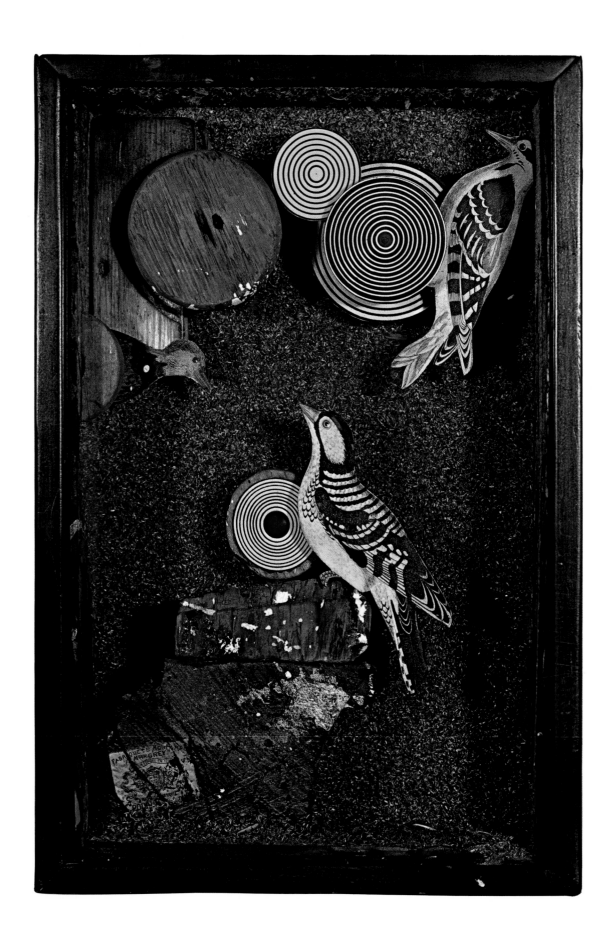

16. *Untitled* [*Woodpecker Habitat*]. 1946.

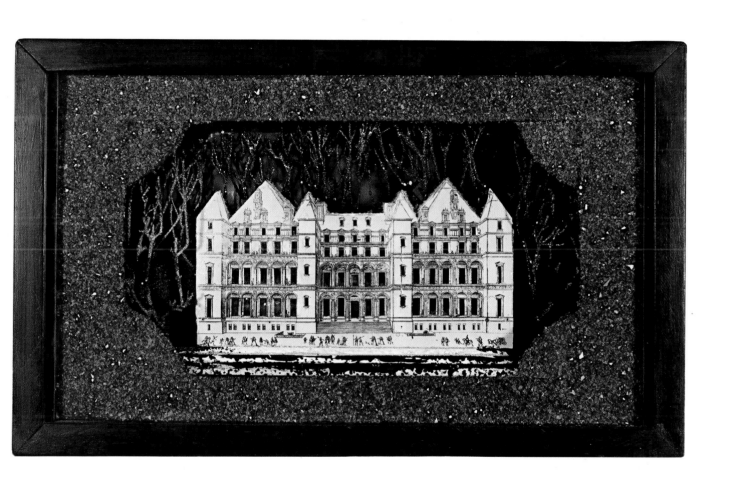

17. *Untitled* [*Pink Palace*]. c. 1946–48.

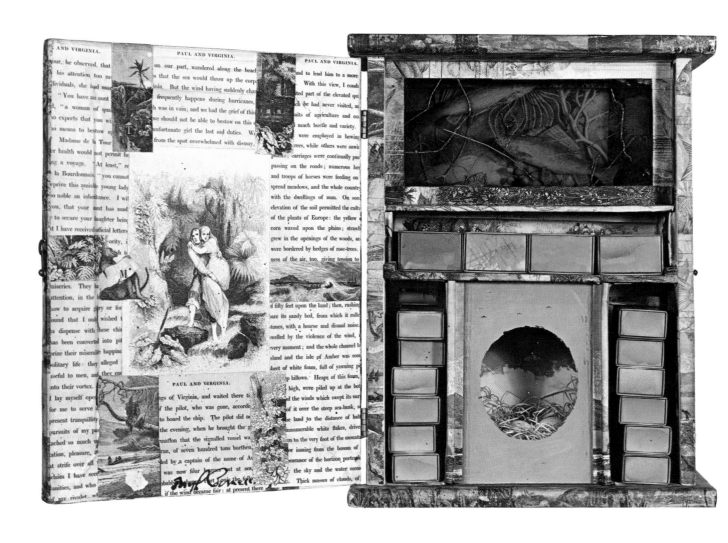

18. *Untitled* [*Paul and Virginia*]. c. 1946–48.

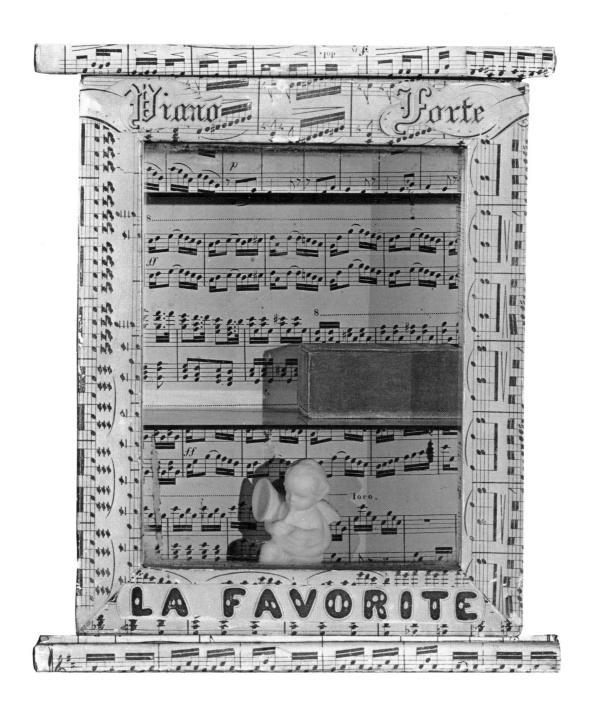

19. *La Favorite.* 1948.

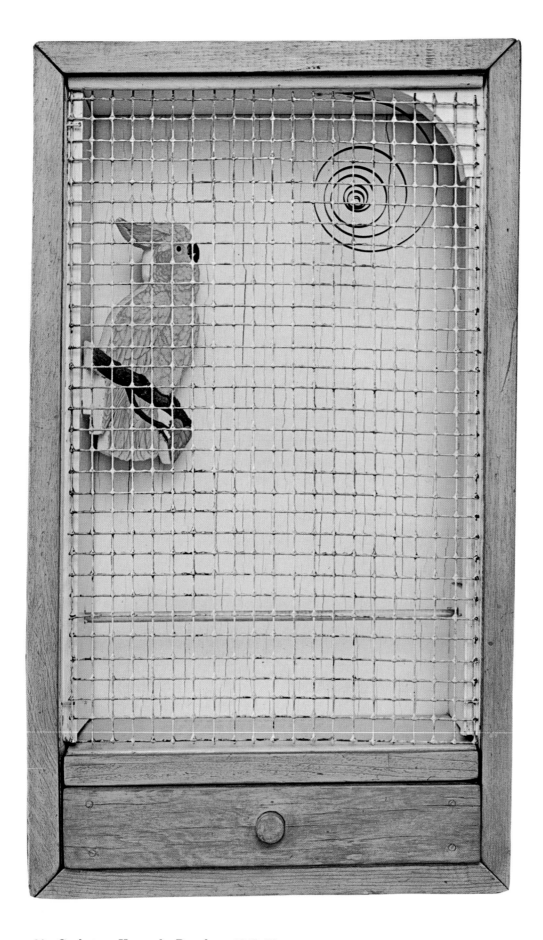

20. *Cockatoo: Keepsake Parakeet.* 1949–53.

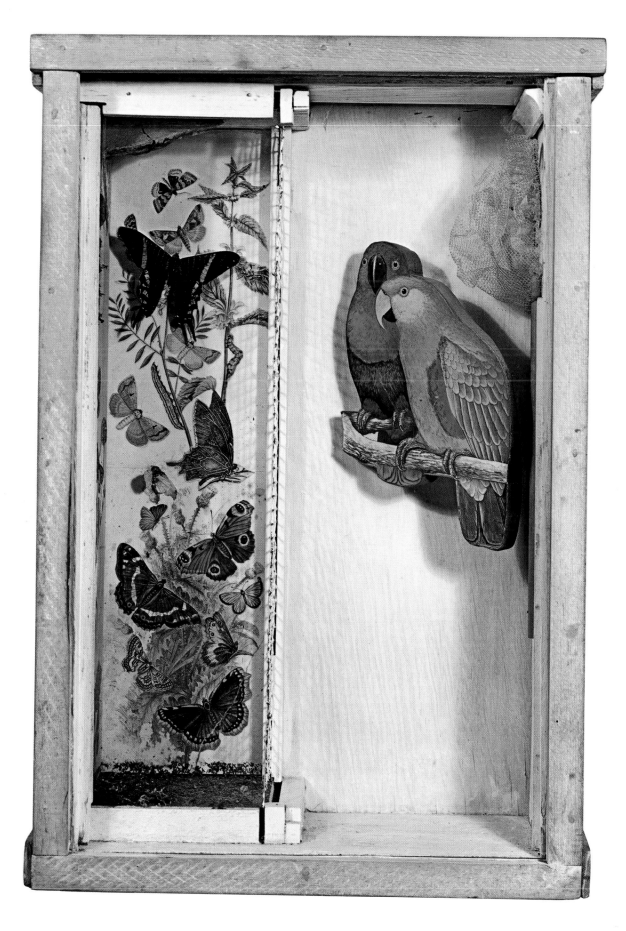

21. *Untitled* [*Parrot and Butterfly Habitat*]. c. 1948.

22. *Forgotten Game.* c. 1949.

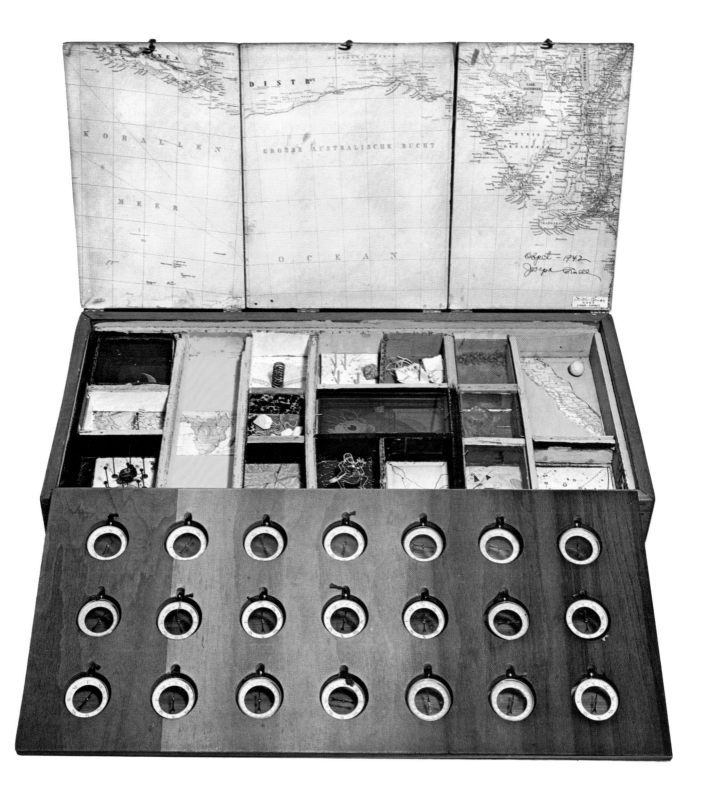

23. *Object (Roses des Vents).* 1942–53.

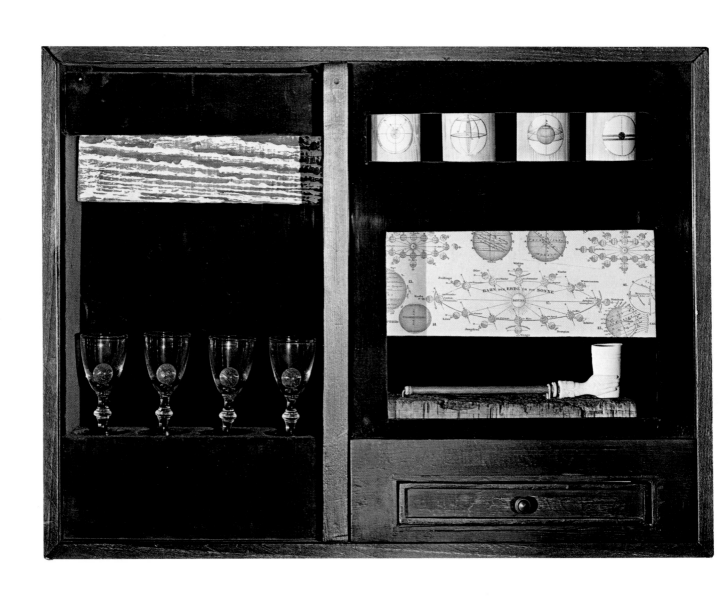

24. *Soap Bubble Set.* 1948.

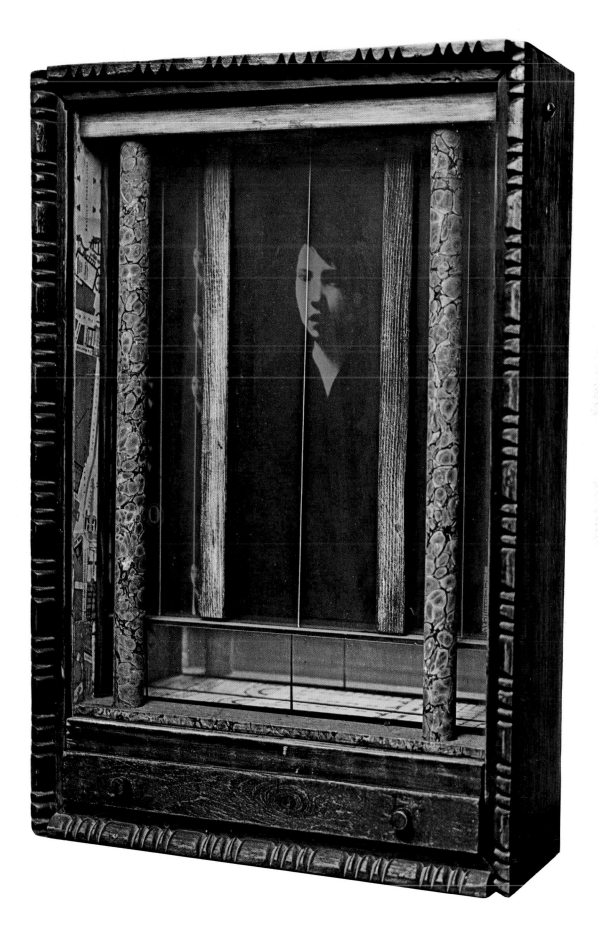

25. *Penny Arcade Machine.* 1950.

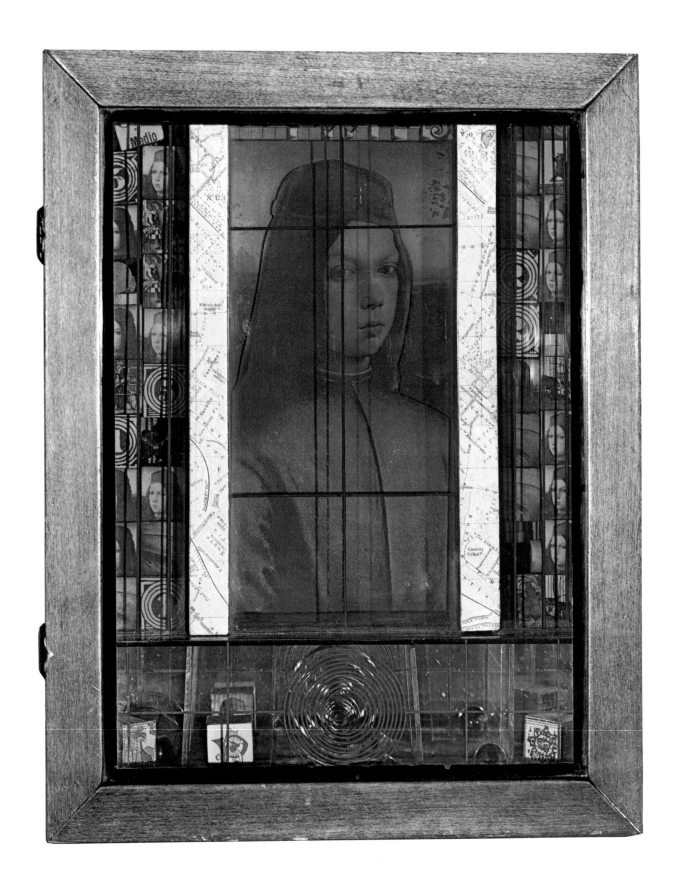

26. *Medici Slot Machine.* 1943.

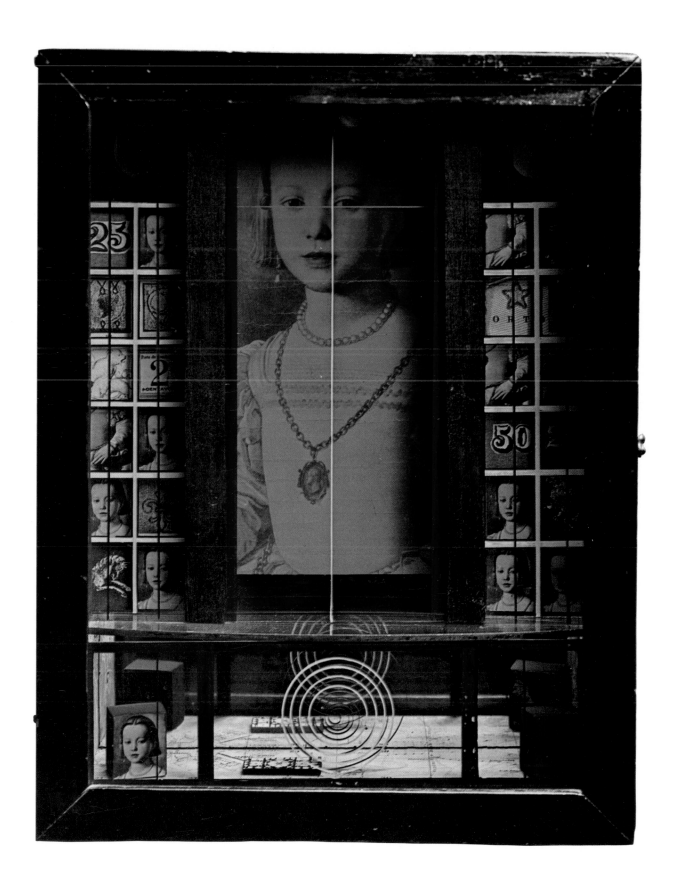

27. *Medici Princess.* 1952.

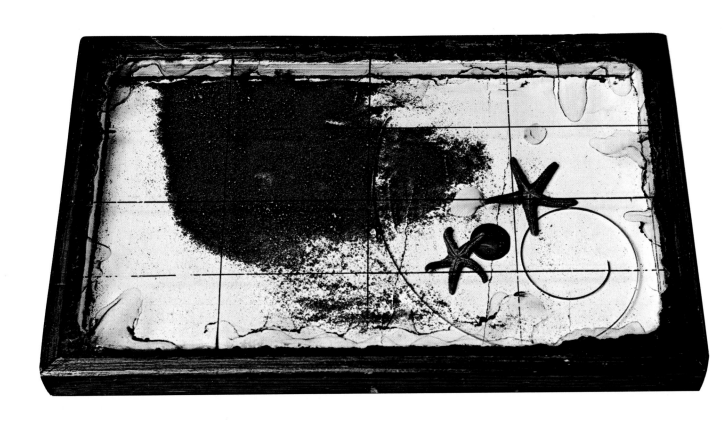

28. *Starfish*. c. 1952.

29. *Pavilion.* 1953.

30. *Hôtel Bon Port (Ann in Memory).* 1954.

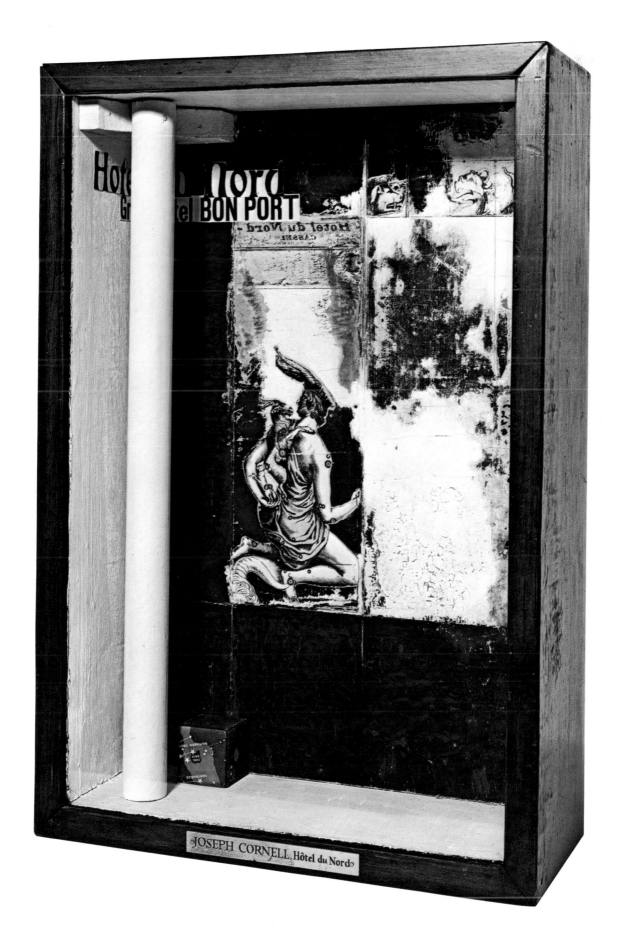

31. *Hôtel du Nord*. c. 1953.

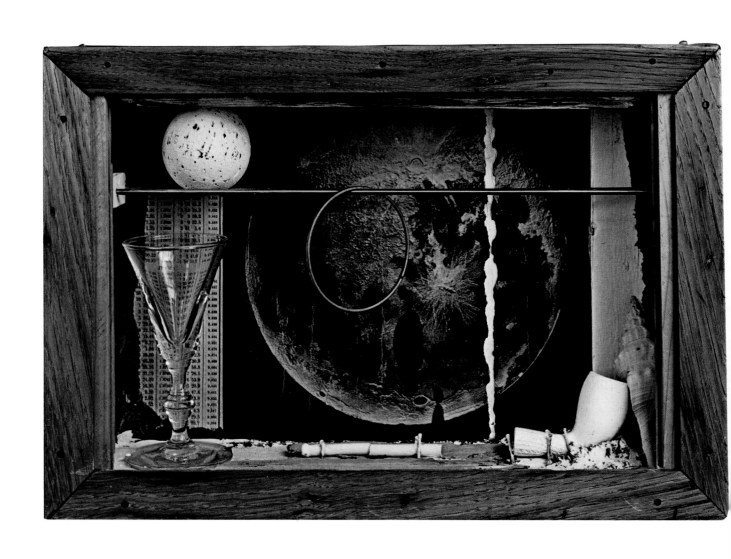

32. *Soap Bubble Set* (*Lunar Space Object*). Late 1950s.

33. *Cauda Draconis.* 1958.

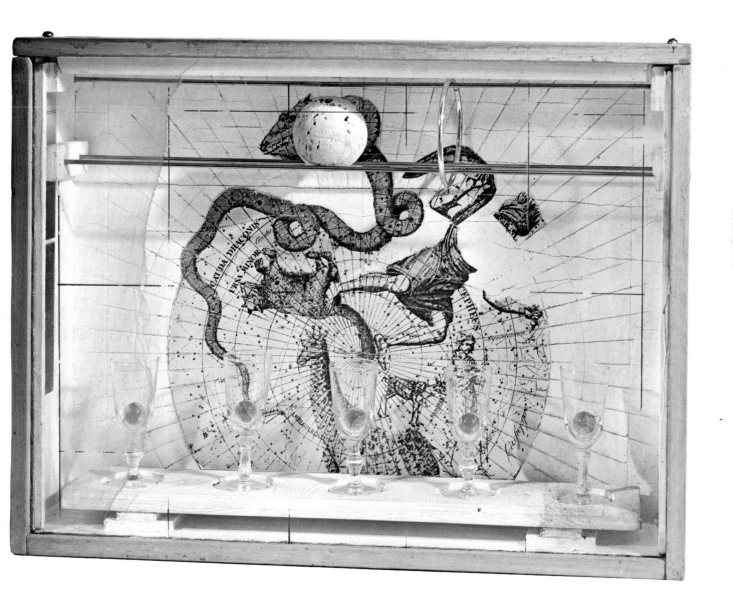

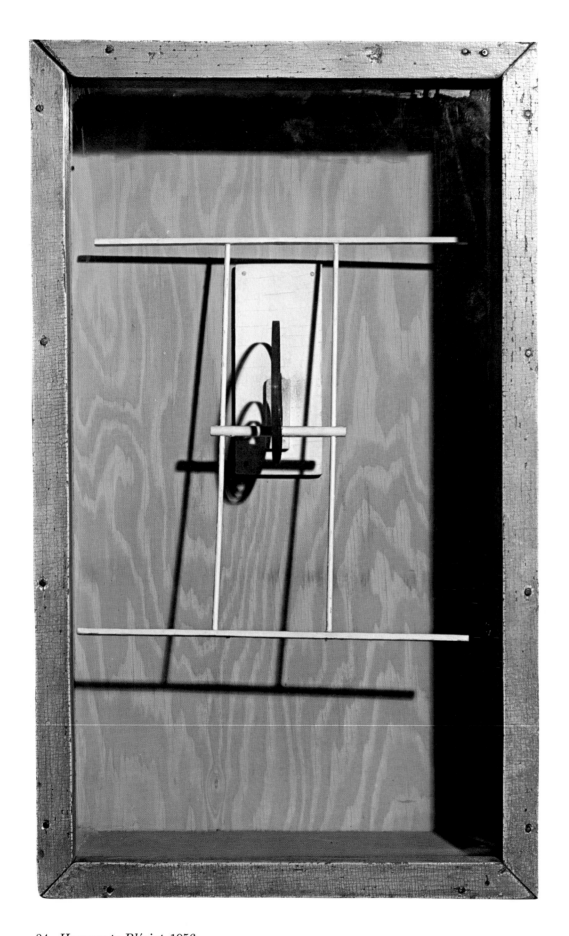

34. *Homage to Blériot.* 1956.

35. *Cassiopeia*. 1963.

36. *The Sister Shades* (front). 1956.

37. *The Sister Shades* (back). 1956.

38. *Interplanetary Navigation.* 1964.

39. *Cassiopeia.* 1966.

40. *The Last Prince of Urbino.* 1967.

41. *Untitled.* 1931.
42. *Untitled.* 1932.

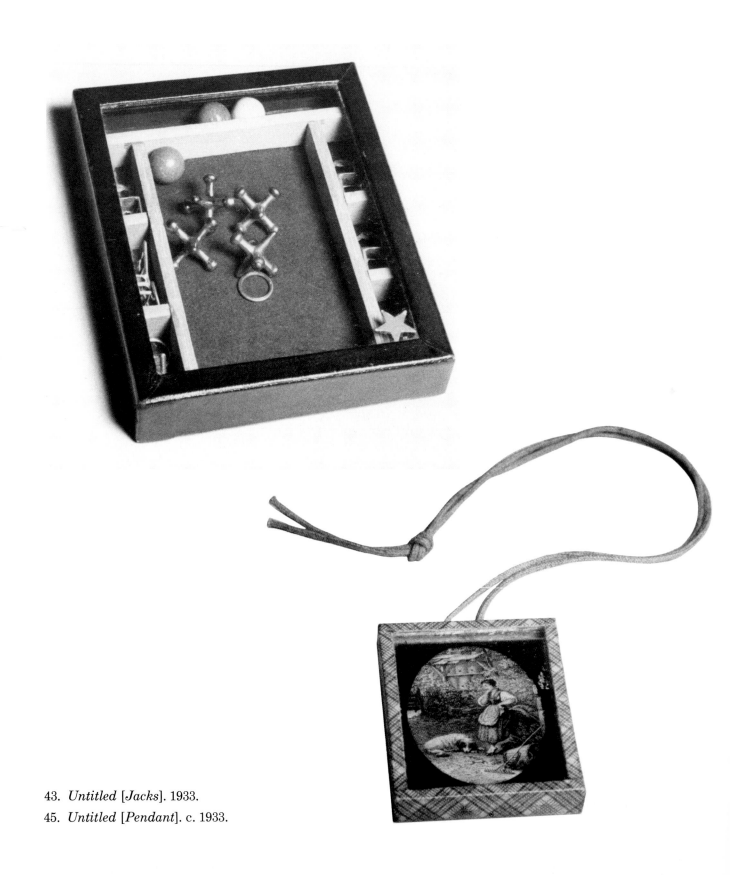

43. *Untitled* [*Jacks*]. 1933.

45. *Untitled* [*Pendant*]. c. 1933.

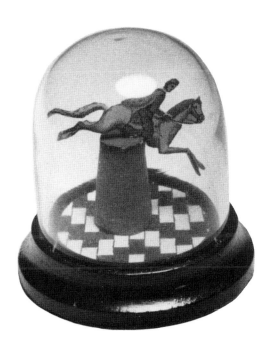

44. *Untitled* [*Horse and Rider*]. c. 1932.
46. *Untitled.* 1933.

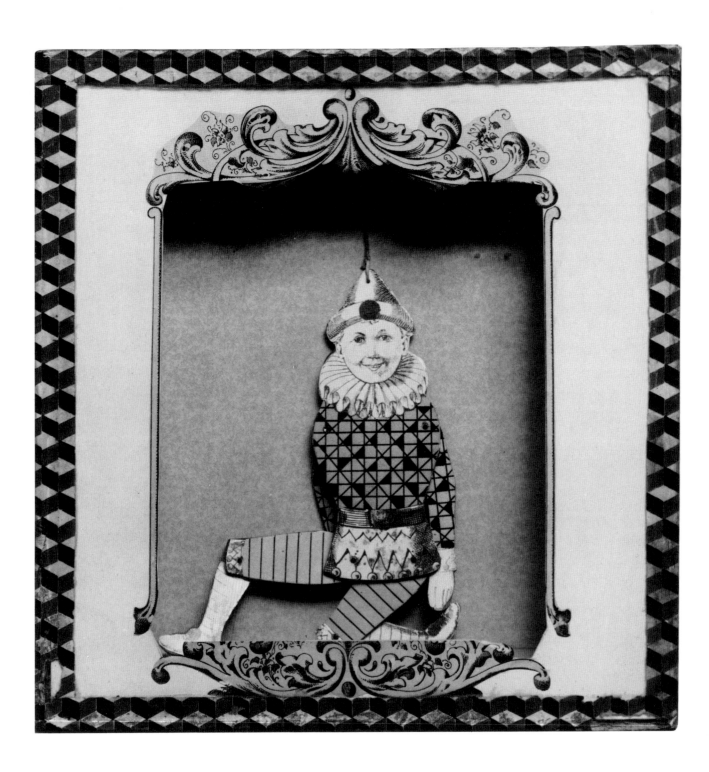

47. *Arlequin.* 1933.

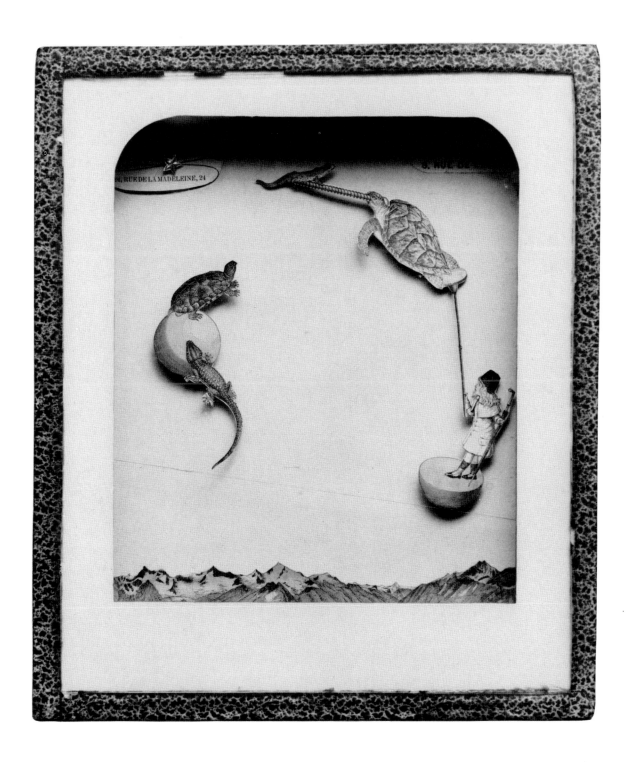

48. *La Bourboule*. c. 1933.

49. *Untitled*. 1933.
50. *Untitled*. 1933.
51. *Untitled*. 1930s.

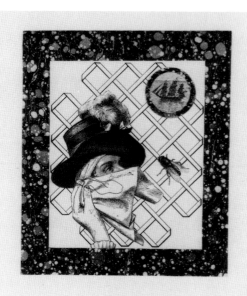

Amiral, ne crois pas déchoir
En agitant ton vieux mouchoir.
C'est la coutume de chasser
Ainsi les mouches du passé.
R. Radiguet

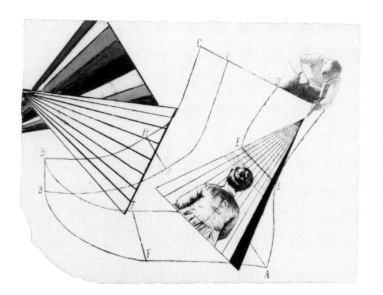

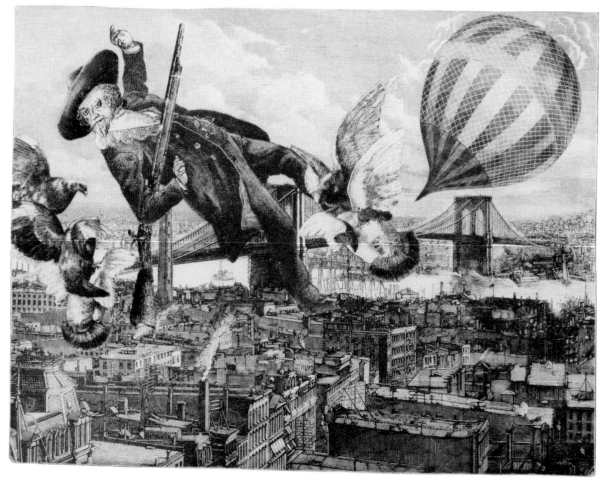

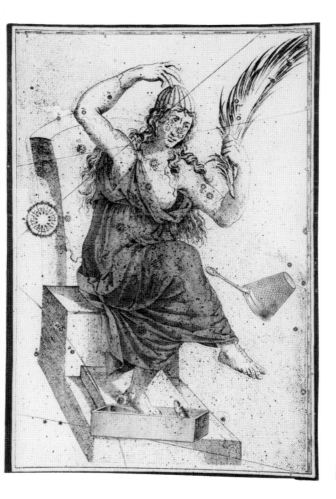

52. *Untitled* [*Constellation*]. 1930s. 53. *Untitled.* Late 1930s.

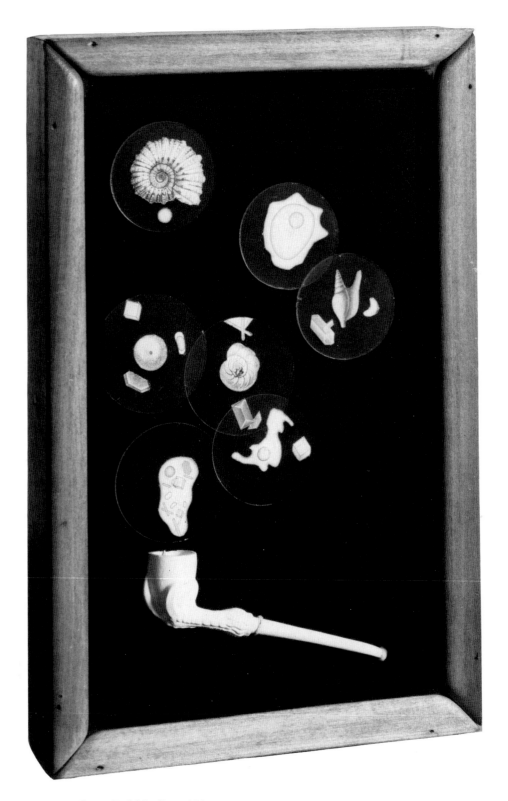

54. *Soap Bubble Set.* 1939.

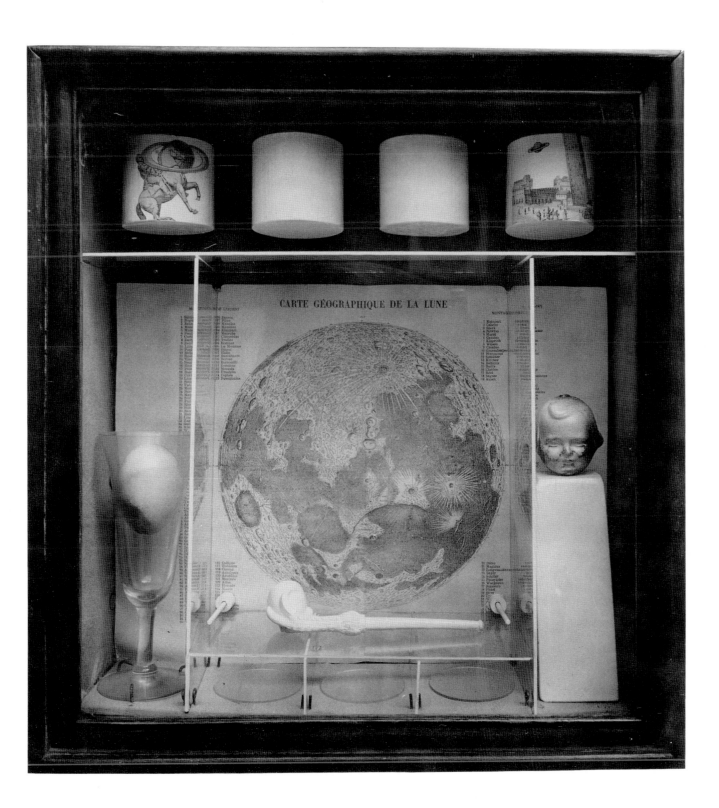

55. *Soap Bubble Set.* 1936.

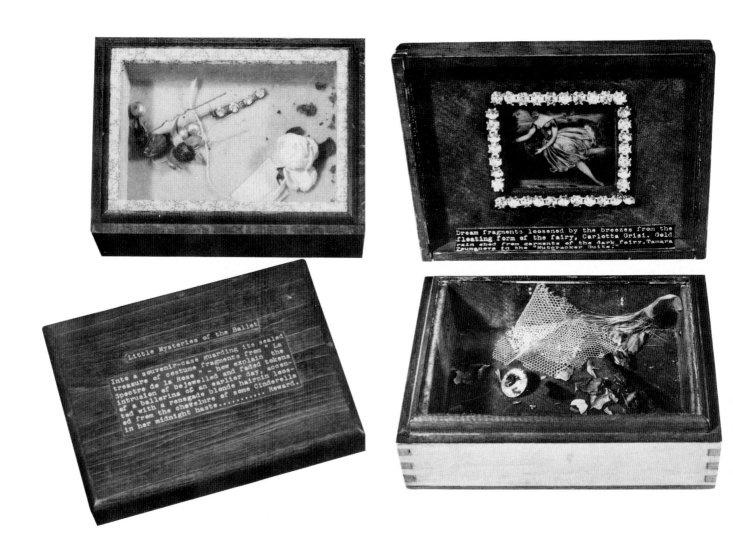

56. *Homage to the Romantic Ballet.* 1941.

57. *Homage to the Romantic Ballet.* 1941.

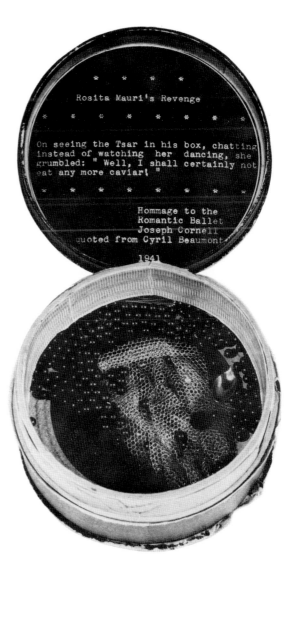

58. *Mémoires Inédits de Madame la Comtesse de G.*
c. 1939.

59. *Homage to the Romantic Ballet* [*Rosita Mauri's Revenge*]. 1941.

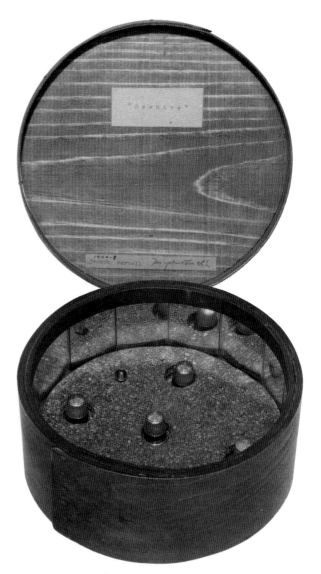

60. *Mémoires de Madame la Marquise de la Rochejaquelein.* 1943.

62. *Beehive.* 1940–48.

61. *Object.* 1940.

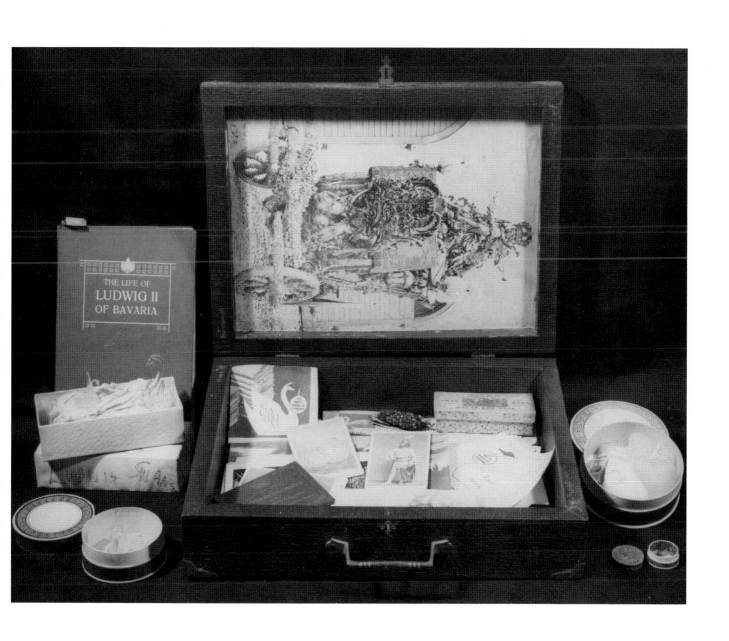

63. *Untitled* [*The Life of Ludwig II of Bavaria*].
c. 1941–52.

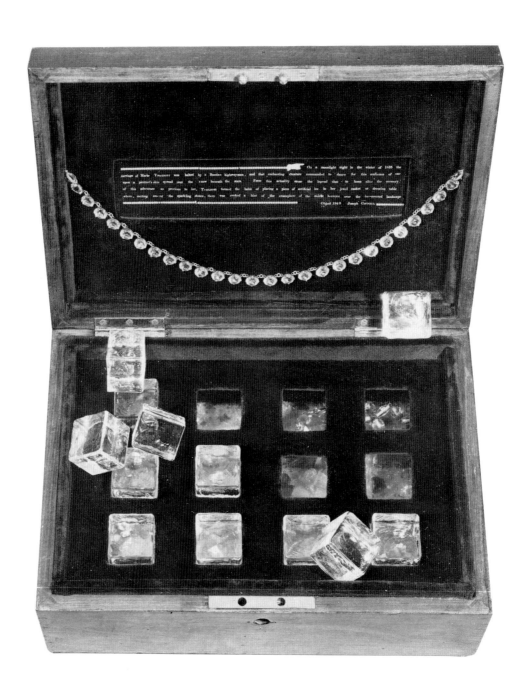

64. *Taglioni's Jewel Casket.* 1940.

65. *Story without a Name—for Max Ernst.* c. 1942.

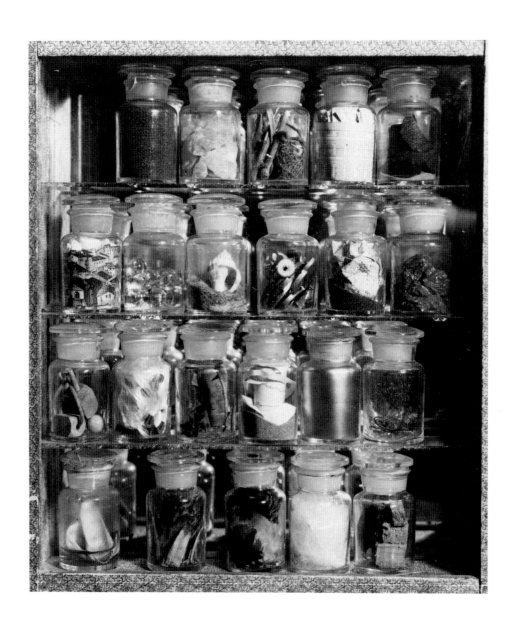

66. *Pharmacy.* 1942.

67. *Hôtel de l'Ange.* 1944.

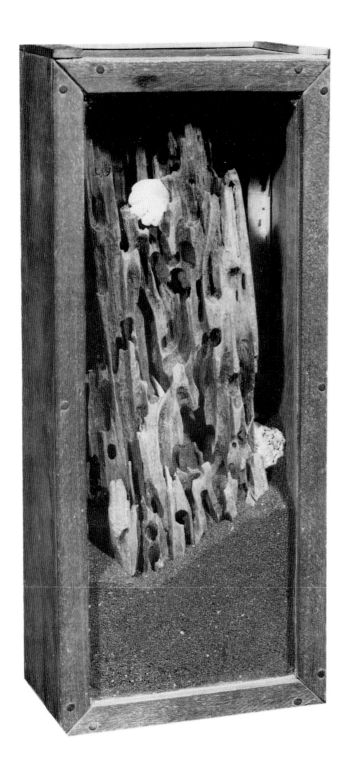

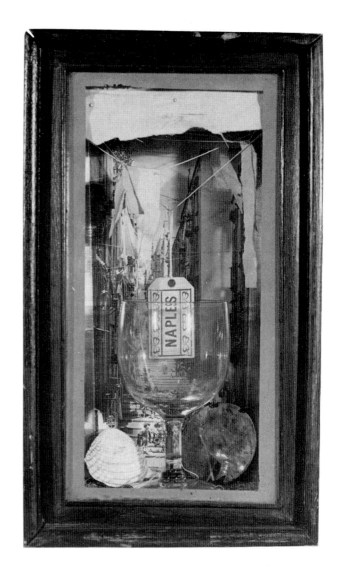

68. *Untitled* [*Sandbox*]. c. 1940. 69. *Naples.* 1942.

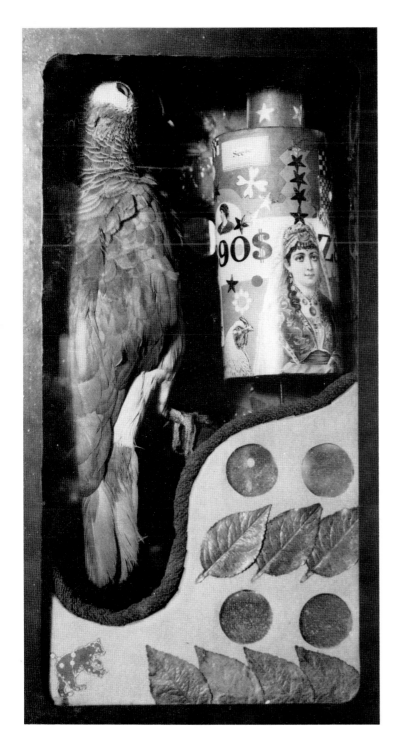

70. *Parrot Music Box*. 1945.

71. *For Stephanie*. c. 1945.

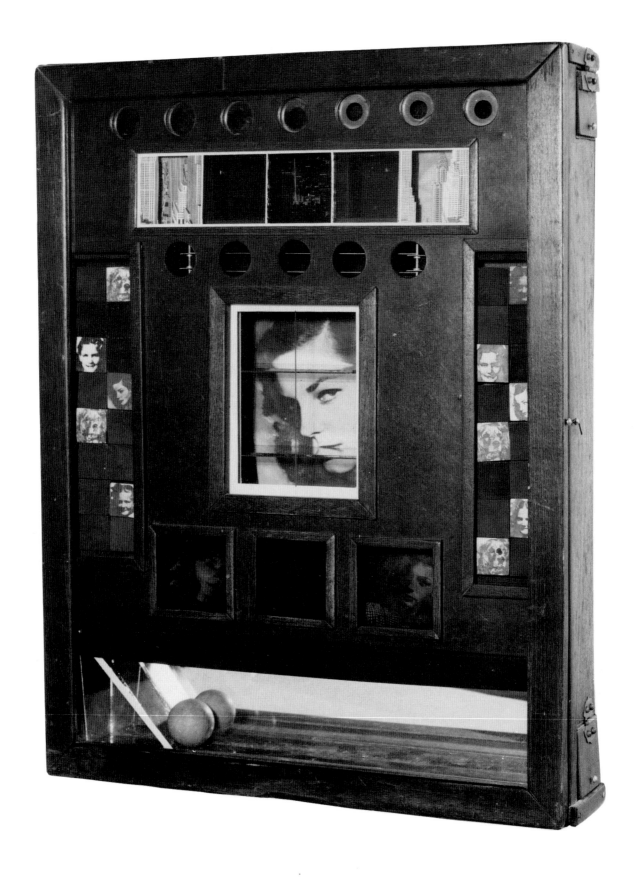

72. *Penny Arcade for Lauren Bacall.* 1946.

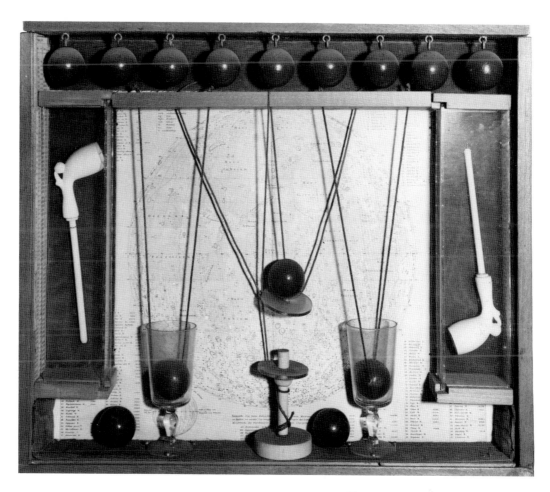

73. *Soap Bubble Set.* 1942.

74. *Music Box.* c. 1947.

75. *Untitled [Star-Game].* c. 1948.

76. *Nouveaux Contes de Fées (Poison Box).* c. 1948.

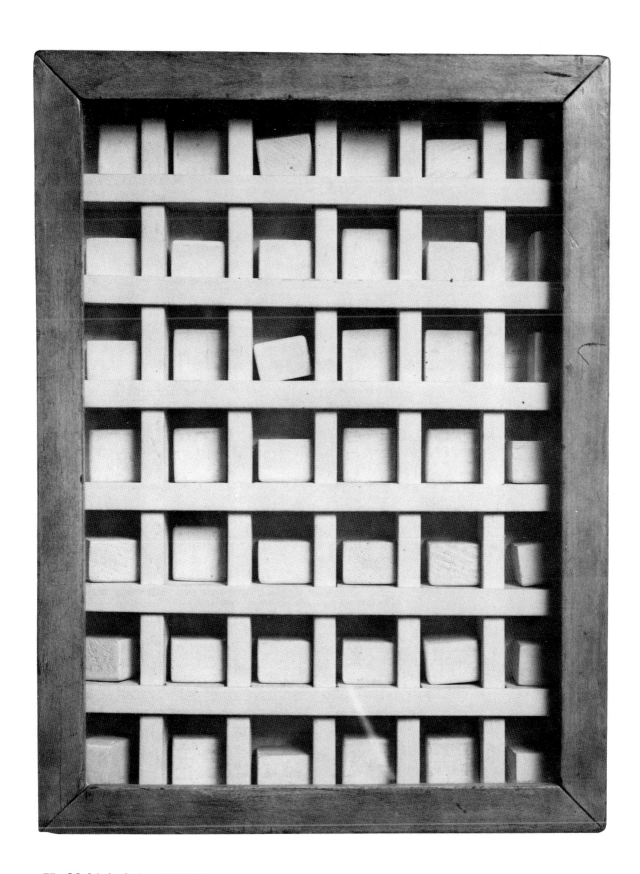

77. *Multiple Cubes.* 1946–48.

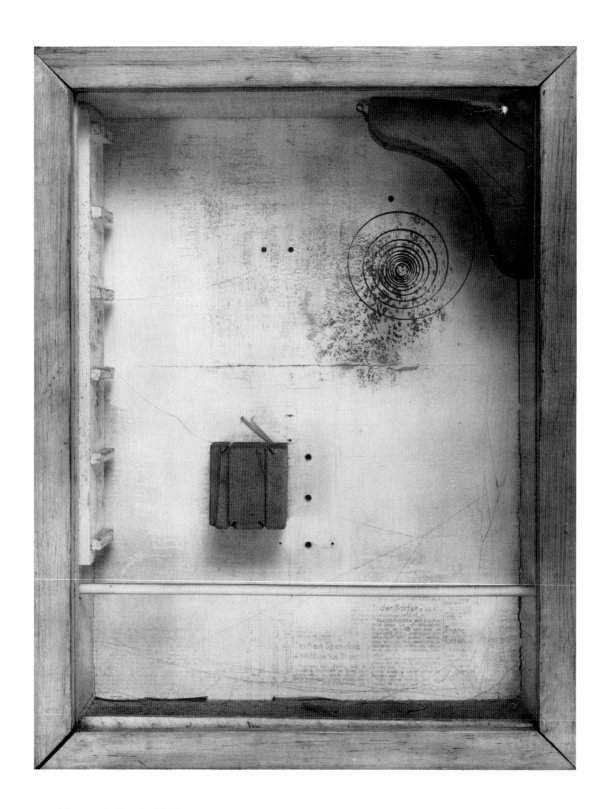

78. *Deserted Perch.* 1949.

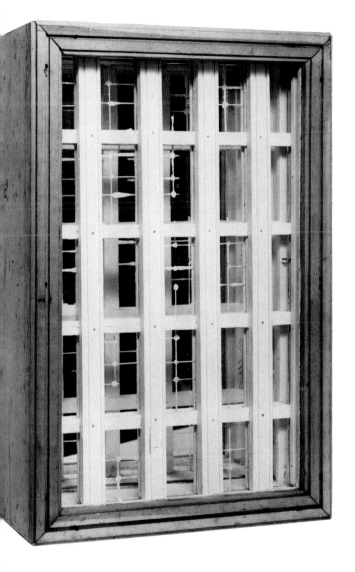

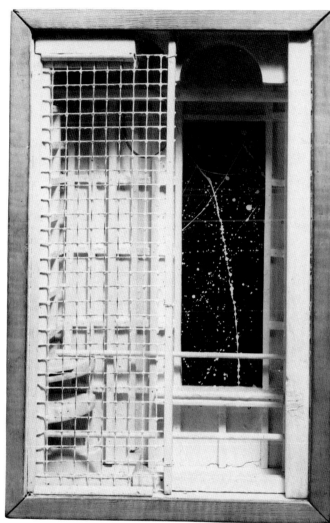

79. *Untitled* [*Windows*]. c. 1950.

80. *Observatory*. 1950.

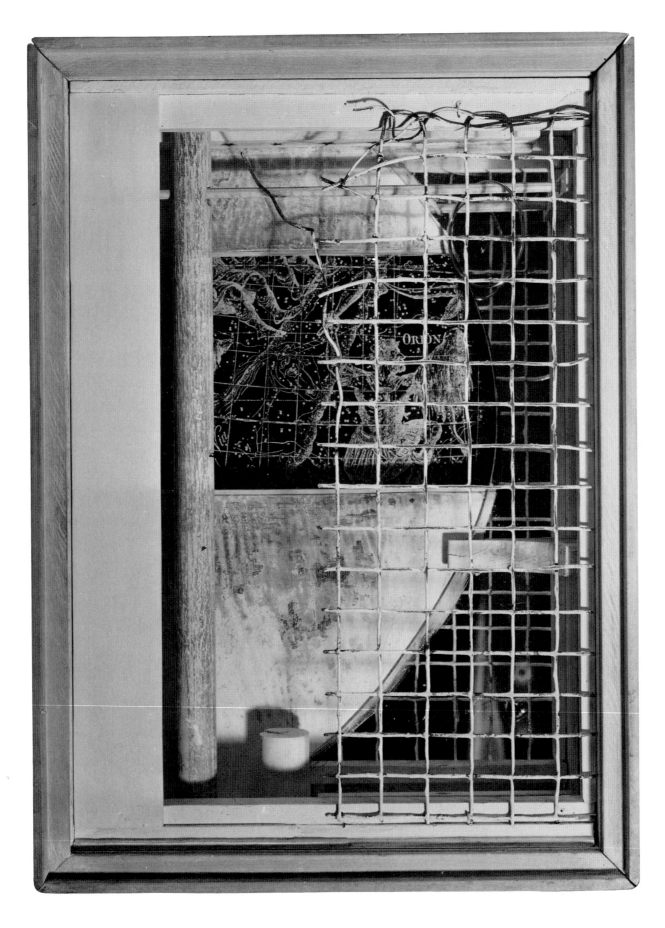

81. *Central Park Carrousel—1950, In Memoriam.* 1950.

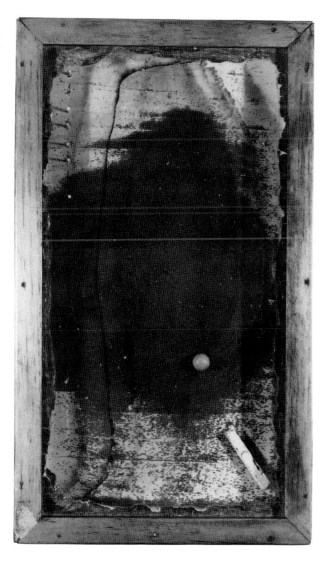

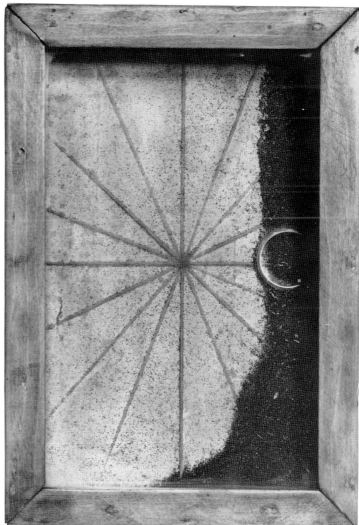

82. *Blue Sandbox.* 1959.

83. *Surrealist Box.* 1951.

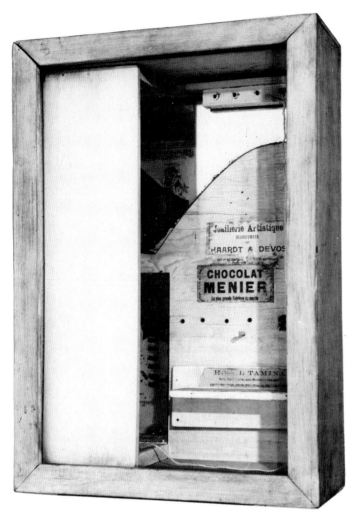

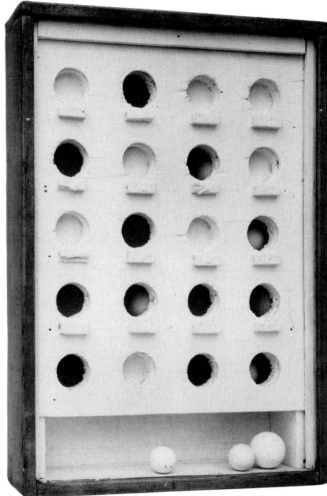

84. *Chocolat Menier.* 1952.

85. *Dovecote.* 1952.

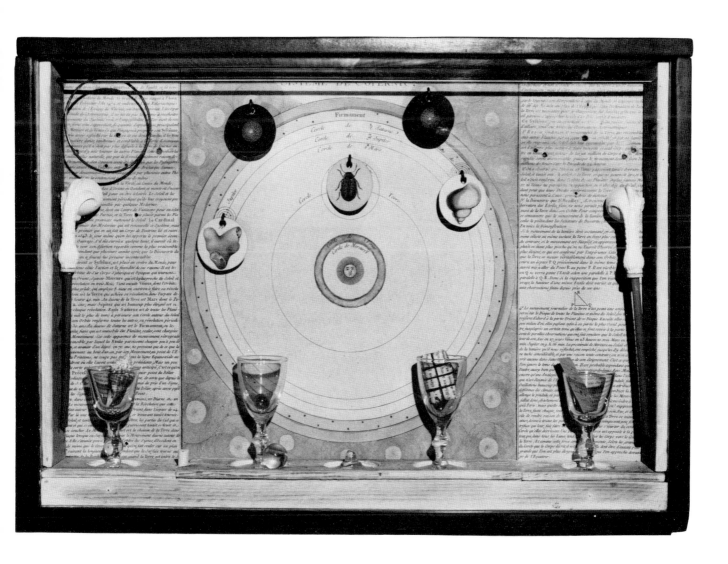

86. *Soap Bubble Set.* 1953.

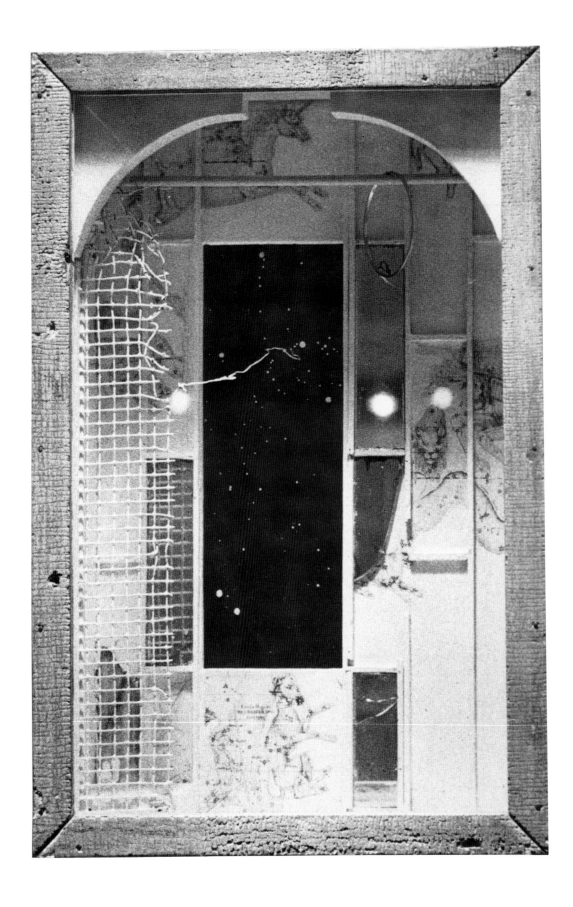

87. *Carrousel.* 1952.

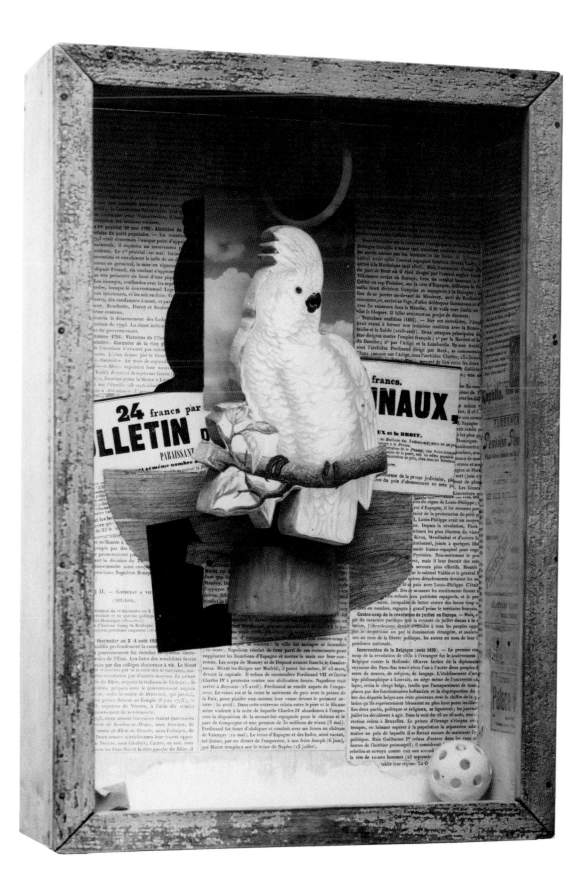

88. *Juan Gris.* 1954.

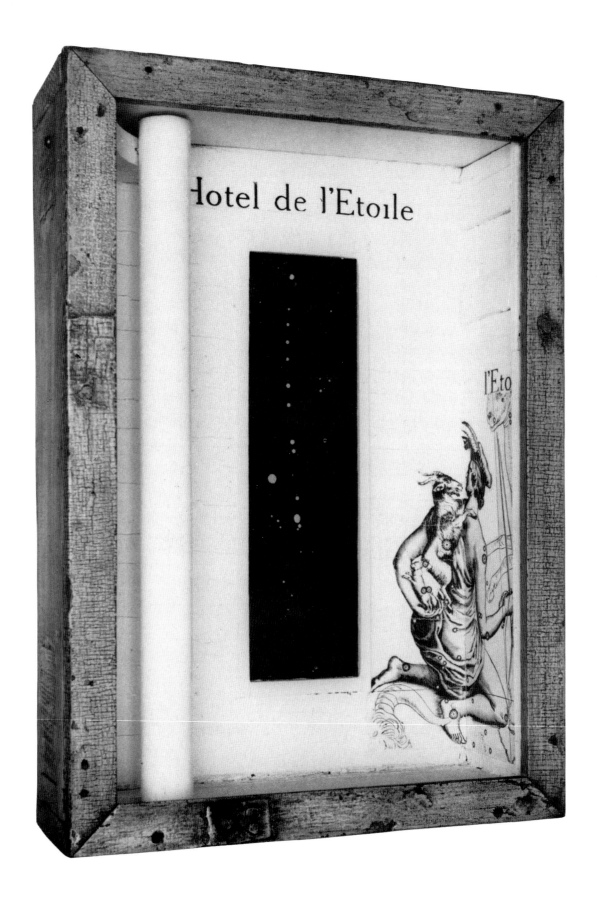

89. *Night Skies: Auriga.* 1954.

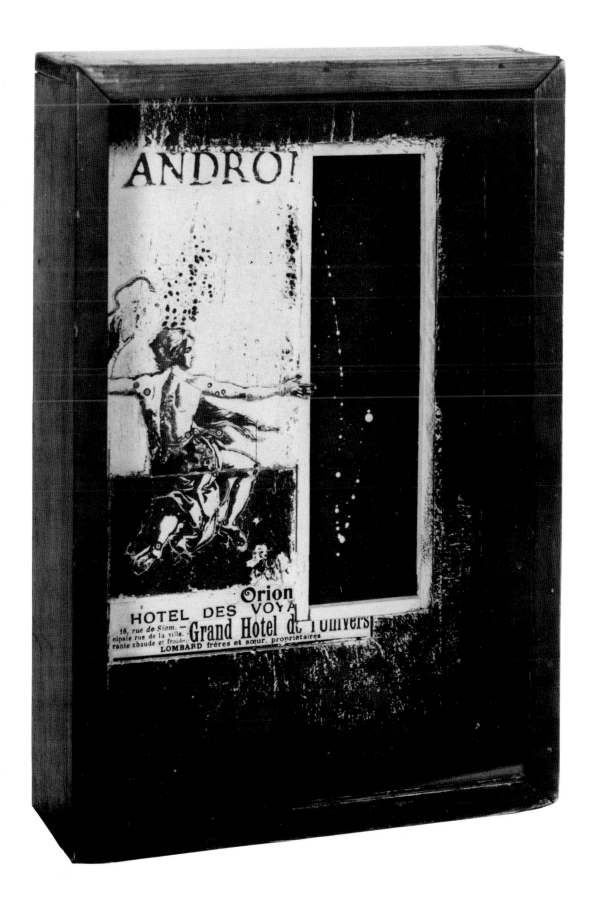

90. *Orion*. 1955.

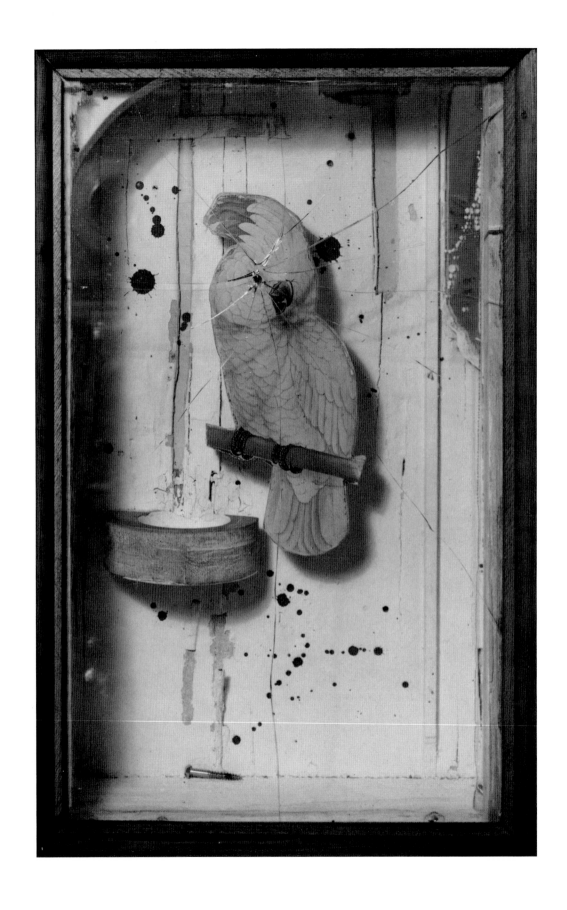

91. *Dien Bien Phu*. 1954.

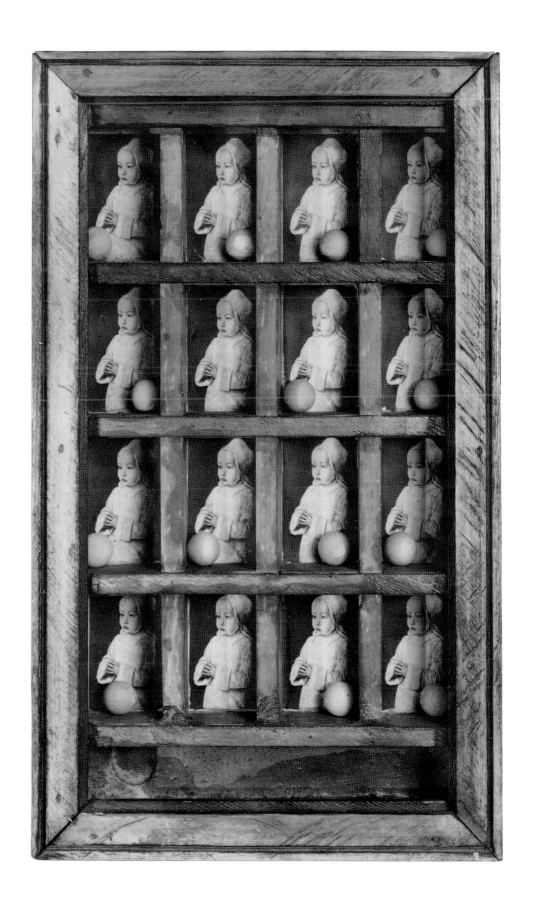

92. *Untitled* [*Flemish Princess*]. Early 1950s.

93. *Sand Fountain.* Late 1950s.

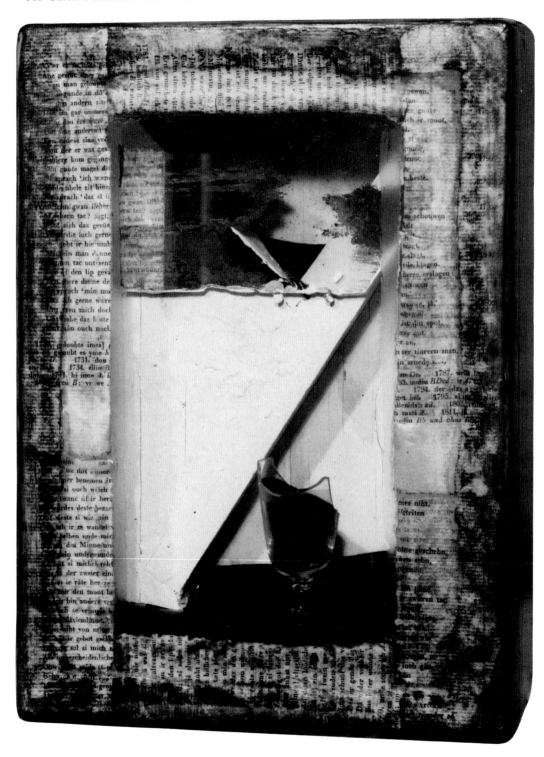

94. *Suite de la Longitude.* c. 1957.
95. *Space Object Box.* Late 1950s.

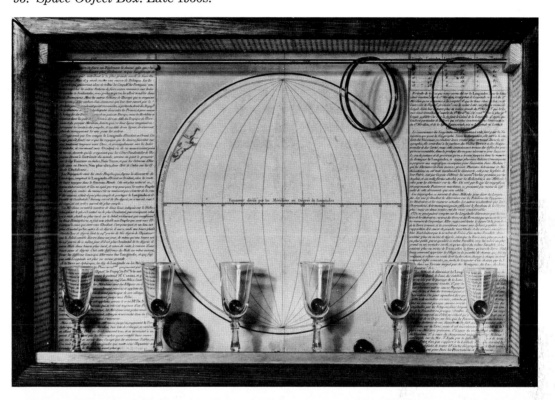

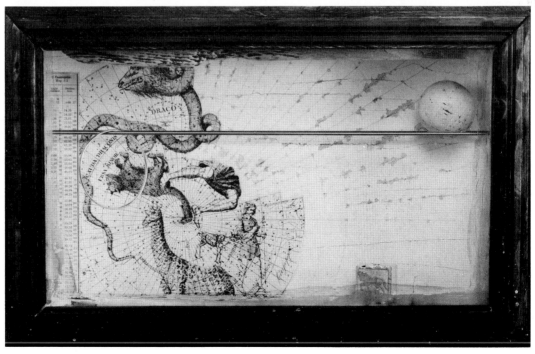

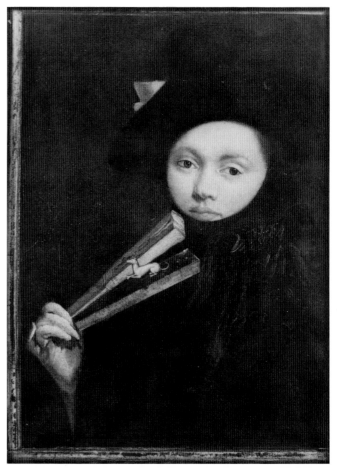

96. *L'Abeille (Pour Jacques Brel le Magnifique)*. 1966.

98. *The Rescue of Perseus by Andromeda*. Late 1950s–early 1960s.

97. *Mica Magritte II*. c. 1965.

99. *André Breton*. 1966.

100. *Couleur de Pêche*. 1967.

NOTES
LIST OF PLATES
BIBLIOGRAPHY

NOTES

[1] Marcel Jean and Arpad Mezei, *The History of Surrealist Painting*, translated by S. W. Taylor (New York: Grove Press, 1960), p. 317; originally published as *Histoire de la Peinture Surréaliste* (Paris: Éditions du Seuil, 1959).

[2] A two-man show also featuring etchings by Picasso. Properly speaking, Cornell's first one-man exhibition was that held at the Julien Levy Gallery in December 1939.

[3] Translated from Comte de Lautréamont, *Les Chants de Maldoror* (Paris and Brussels, 1874), p. 290.

[4] Anna Balakian, *Surrealism: The Road to the Absolute* (New York: Noonday, 1959), p. 14.

[5] André Breton, *What is Surrealism?*, translated by David Gascoyne (London: Faber and Faber, 1936), p. 50.

[6] Balakian, *Surrealism*, p. 56.

[7] Julien Levy, *Surrealism* (New York: Black Sun Press, 1936), p. 22.

[8] Exhibition catalogue, *Joseph Cornell: Objects*, Copley Galleries, Beverly Hills, Sept. 28, 1948.

[9] "Monsier Phot," in Levy, *Surrealism*, p. 83.

[10] *Ibid.*, p. 84.

[11] André Breton, "World," quoted in Marcel Jean, *The History of Surrealist Painting* (New York: Grove, 1960), p. 146.

[12] *View*, 2:4 (Jan. 1943), p. 12.

[13] Brochure for Cornell exhibition, *Portraits of Women—Constructions and Arrangements*, Hugo Gallery, New York, Dec. 1946.

[14] T[homas] B. H[ess], "Reviews and Previews," *Art News*, 48:9 (Jan. 1950), p. 45.

[15] Quoted by Ernst in "Au delà de la peinture," *Cahiers d'Art*, 2:6–7 (1936), n.p.; reprinted in Max Ernst, *Beyond Painting and Other Writings by the Artist and His Friends,* edited by Robert Motherwell (New York, 1948), pp. 4–5.

[16] Letter from Cornell to John I. H. Baur regarding his participation in the Whitney Annual of 1962.

[17] Parker Tyler, "Joseph Cornell," *Art News*, 56:9 (Jan. 1959), pp. 18–19.

[18] Michel Seuphor, "Piet Mondrian: 1914–1918," *Magazine of Art*, 45:5 (May 1952), p. 217.

[19] Conversation with Joseph Cornell, 1963–64.

[20] Conversation with Joseph Cornell, 1963–64.

[21] Jean, *History of Surrealist Painting*, p. 314.

[22] Howard Griffin, "Auriga, Andromeda, Cameoleopardalis," *Art News*, 56:8 (Dec. 1957), p. 64.

[23] Robert Motherwell, "Preface to a Joseph Cornell Exhibition," Walker Art Center, Minneapolis, July 12–Aug. 30, 1953 (unpublished catalogue). The preface has now been published in the catalogue for *Joseph Cornell*, Leo Castelli Gallery, New York, Feb. 28–March 20, 1976.

LIST OF PLATES

1. *Snow Maiden.* 1932–33.
Construction, 13¼ × 13¼ × 2½″.
Collection Mr. and Mrs. Edwin A. Bergman, Chicago.

2. *Défense d'Afficher.* 1939.
Construction, 8¹⁵⁄₁₆ × 13¹⁵⁄₁₆ × 2⅛″.
The title is painted on glass, mounted in the cutout silhouette of
 the dancer. Inscribed on the back: "Annie St. Stel,
 dancer/Ca. 1885+."
Collection Mr. and Mrs. Kenneth Donahue, Los Angeles.

3. *Black Hunter.* 1939.
Construction, 8 × 11⅞ × 2¾″.
Collection Mr. and Mrs. Edwin A. Bergman, Chicago.

4. *A Dressing Room for Gille.* 1939.
Construction, 15 × 8⅝ × 5¹¹⁄₁₆″.
The figure is after Watteau's portrait of *Gilles* in the Louvre.
Private Collection.

5. *Untitled [Butterfly Habitat].* c. 1940.
Construction, 12 × 9⅛ × 3³⁄₁₆″.
Collection Mr. and Mrs. Edwin A. Bergman, Chicago.

6. *Paolo and Francesca.* 1943–48.
Construction, 14¾ × 11⅜ × 3¹³⁄₁₆″.
The subject is taken from Dante's *Inferno,* fifth canto; see also
 Leigh Hunt's poem "The Story of Rimini."
Collection Richard L. Feigen, New York.

7. *Object.* 1940.
Construction, 9⅛ × 14⅛ × 3⁷⁄₁₆″.
Inscription reads: "les abeilles ont attaqué le bleu céleste pâle."
Collection Mr. and Mrs. Frederick R. Weisman, Beverly Hills,
 California.

8. *A Pantry Ballet (for Jacques Offenbach).* Summer 1942.
Construction, 10½ × 18 × 6″.
Collection Richard L. Feigen, New York.

9. *L'Égypte de Mlle Cléo de Mérode cours élémentaire d'histoire
 naturelle.* 1940.
Construction, 4¹¹⁄₁₆ × 10¹¹⁄₁₆ × 7¼″.
Collection Richard L. Feigen, New York.

10. *Habitat Group for a Shooting Gallery.* 1943.
Construction, 15½ × 11⅛ × 4¼″.
Des Moines Art Center, Iowa (Coffin Fine Arts Trust Fund, 1975).

11. *Medici Slot Machine.* 1942.
Construction, 15½ × 12 × 4⅜″.
The central image is a reproduction of the *Portrait of a Young
 Noble* in the Walters Art Gallery, Baltimore, a painting
 formerly attributed to G. B. Moroni but now assigned to
 Sofonisba Anguissola. Flanking the image are sections of a
 map showing the remains of the ancient Roman imperial
 palace on the Palatine hill in Rome.
The Reis Family Collection, New York.

12. *Pharmacy.* 1943.
Construction, 15¼ × 12 × 3⅛″.
Collection Mrs. Marcel Duchamp, Paris.

13. *Untitled [Cork or Varia Box].* c. 1943.
Construction, 2¼ × 17 × 10⅝″ (lid).
Collection Mr. and Mrs. Edwin A. Bergman, Chicago.

14. *American Rabbit.* 1945–46.
Construction, 11⅓ × 15½ × 2¾″.
Collection Mr. and Mrs. Edwin A. Bergman, Chicago.

15. *The Hotel Eden.* 1945.
Construction, 15⅛ × 15¾ × 4¾″.
National Gallery of Canada, Ottawa.

16. *Untitled [Woodpecker Habitat].* 1946
Construction, 13⅝ × 8¹⁵⁄₁₆ × 2¹⁵⁄₁₆″.
Collection Mr. and Mrs. Edwin A. Bergman, Chicago.

17. *Untitled [Pink Palace].* c. 1946–48.
Construction, 10 × 16⁷⁄₁₆ × 3¾″.
Printed on the back: "Alcibiade fait ici allusion" followed by a
 Greek inscription.
Collection François de Menil, New York.

18. *Untitled [Paul and Virginia].* c. 1946–48.
Construction, 12⁵⁄₁₆ × 9¹⁵⁄₁₆ × 4¼″.
Hinged door has a mirror on the exterior. Book pages are from
 an English translation of the romance by Bernardin de St.
 Pierre, *Paul et Virginie* (1787).
Collection Mr. and Mrs. Edwin A. Bergman, Chicago.

19. *La Favorite.* 1948.
Construction, 10 × 8⅝ × 4⅝″.
Collection Mr. and Mrs. Edwin A. Bergman, Chicago.

20. *Cockatoo: Keepsake Parakeet.* 1949–53.
Construction, 20¼ × 12 × 5″.
Collection Donald Windham, New York.

21. *Untitled [Parrot and Butterfly Habitat].* c. 1948.
Construction, 19⅝ × 13⅝ × 6½″.
Collection the Estate of Joseph Cornell. Courtesy Castelli/
 Corcoran/Feigen.

22. *Forgotten Game.* c. 1949.
Construction, 21 × 15½ × 4″.
Collection Mr. and Mrs. Edwin A. Bergman, Chicago.

23. *Object (Roses des Vents).* 1942–53.
Construction, 21¼ × 10⅜ × 2⅝″.
Museum of Modern Art, New York (Mr. and Mrs. Gerald
 Murphy Fund).

24. *Soap Bubble Set.* 1948.
Construction, 15¼ × 20⅜ × 3¼″.
Astronomical chart shows the path of earth around the sun
 ("Bahn der Erde um die Sonne").
Collection Mr. and Mrs. Edwin A. Bergman, Chicago.

25. *Penny Arcade Machine.* 1950.
Construction, 18 × 12¼ × 4¼″.
Collection Muriel Kallis Newman, Chicago.

26. *Medici Slot Machine.* 1943.
Construction, 14 × 11 × 4″.
Central image is a reproduction of Bernardo Pinturicchio's
 Portrait of a Boy (Royal Gallery, Dresden).
Collection Mr. and Mrs. Edwin A. Bergman, Chicago.

27. *Medici Princess.* 1952.
Construction, 14 × 11 × 4″.

Central image is a reproduction of Agnolo Bronzino's portrait
 of *Bia di Cosimo de' Medici* (Uffizi, Florence).
Collection Mr. and Mrs. Edwin A. Bergman, Chicago.

28. *Starfish.* c. 1952.
Construction, 9½ × 15½ × 1¼″.
Collection Mr. and Mrs. Joseph R. Shapiro, Oak Park, Illinois.

29. *Pavilion.* 1953.
Construction, 19 × 12 × 6½″.
Collection Mr. and Mrs. Edwin A. Bergman, Chicago.

30. *Hôtel Bon Port* (*Ann in Memory*). 1954.
Construction, 13 × 10½ × 3¼″.
Collection Mr. and Mrs. Edwin A. Bergman, Chicago.

31. *Hôtel du Nord.* c. 1953.
Construction, 19 × 13¼ × 5½″.
Whitney Museum of American Art, New York.

32. *Soap Bubble Set* (*Lunar Space Object*). Late 1950s.
Construction, 9¾ × 14½ × 3¾″.
Collection Rhett and Robert Delford Brown, New York.

33. *Cauda Draconis.* 1958.
Construction, 13⅛ × 18 × 4″.
Courtesy Xavier Fourcade, Inc., New York.

34. *Homage to Blériot.* 1956.
Construction, 18½ × 11¼ × 4¾″.
Collection Mr. and Mrs. Edwin A. Bergman, Chicago.

35. *Cassiopeia.* 1963.
Collage with watercolor, 11½ × 8½″.
The figure is cut out from a reproduction of Piero della Fran-
 cesca's *Madonna and Child with Four Angels* (Clark Institute,
 Williamstown, Massachusetts).
Collection Mr. and Mrs. Edwin A. Bergman, Chicago.

36. *The Sister Shades* (front). 1956.
Collage, 12 × 9″.
Courtesy Xavier Fourcade, Inc., New York.

37. *The Sister Shades* (back). 1956.
Collage includes pages from a German theological text and a
 printed scrap reading: "...conversation softening the
 tempers of women, or to our tyranny, breaking their spirits,
 that wives and widows are so much better...." Handwritten
 inscription above, "amber glass for maximum effect," is
 recapitulated in a typewritten inscription below: "stained
 clear amber glass essential for effect... [illegible]," followed
 by signature. Typewritten inscription above gives title and
 explains collage elements used on the front: " 'The Sister
 Shades' #2. Jackie Lane—1956. English starlet. Detail of
 boys from Murillo."

38. *Interplanetary Navigation.* 1964.
Collage with watercolor, 11⅜ × 8½″.
Solomon R. Guggenheim Museum, New York (Gift of Mr. and
 Mrs. Walter N. Pharr).

39. *Cassiopeia.* 1966.
Collage with oil, 9 × 11¾″.
Reproduction is of Dosso Dossi's *Circe and Her Lovers in a
 Landscape,* c. 1525 (National Gallery, Washington, D.C.).
Collection Mr. and Mrs. Edwin A. Bergman, Chicago.

40. *The Last Prince of Urbino.* 1967.
Collage, 12 × 9″.
Private Collection, New York.

41. *Untitled.* 1931.
Collage, 4½ × 5¾″.
Collection June W. Steinmetz, Pasadena, California.

42. *Untitled.* 1932.
Collage, 5¼ × 8⅛″.
Collection the Estate of Joseph Cornell.

43. *Untitled* [*Jacks*]. 1933.
Construction, 4⅛ × 5½ × ⅜″.
Collection Mr. and Mrs. Edwin A. Bergman, Chicago.

44. *Untitled* [*Horse and Rider*]. c. 1932.
Construction, 1⅞ × 1⅞″ diam.
Collection Mr. and Mrs. Edwin A. Bergman, Chicago.

45. *Untitled* [*Pendant*]. c. 1933.
Construction, 2½ × 2 × ⅜″.
Collection Mr. and Mrs. Edwin A. Bergman, Chicago.

46. *Untitled.* 1933.
An arrangement of four constructions: 3³⁄₁₆ × 4¹¹⁄₁₆ × ¾″ (above);
 1 × 2¾″ diam. (left); 2 × 2¹³⁄₁₆″ diam. (right); ½ × 1¼″ diam.
 (center).
Collection Sterling Holloway, South Laguna Beach, California.

47. *Arlequin.* 1933.
Construction, 13 × 12½ × 2¾″.
Collection Mr. and Mrs. Edwin A. Bergman, Chicago.

48. *La Bourboule.* c. 1933.
Construction, 14¼ × 12¼ × 2½″.
Collection Mr. and Mrs. Edwin A. Bergman, Chicago.

49. *Untitled.* 1933.
Collage with ink, 7½ × 10″.
Collection the Estate of Joseph Cornell.

50. *Untitled.* 1933.
Collage, 10 × 7½″.
Inscription reads: "Amiral, ne crois pas déchoir / En agitant
 ton vieux mouchoir. / C'est la coutume de chasser / Ainsi les
 mouches du passé. / R. Radiguet."
Collection the Estate of Joseph Cornell.

51. *Untitled.* 1930s.
Collage, 7½ × 10″.
Collection the Estate of Joseph Cornell.

52. *Untitled* [*Constellation*]. 1930s.
Collage with ink, 9⅜ × 7⅛″.
Collection the Estate of Joseph Cornell.

53. *Untitled.* Late 1930s.
Collage, 7¼ × 5¾″.
Collection the Estate of Joseph Cornell.

54. *Soap Bubble Set.* 1939.
Construction, 14 × 9 × 2⅛″.
Collection Mr. and Mrs. Edwin A. Bergman, Chicago.

55. *Soap Bubble Set.* 1936.
Construction, 15¾ × 14¼ × 5⁷⁄₁₆″.
Wadsworth Atheneum, Hartford.

56. *Homage to the Romantic Ballet.* 1941.
Construction, 1¾ × 4½ × 3½″.
Typed inscription on lid interior reads: "pink slipper-lace, silver
 hairpin, white rose—actual pieces from the ballet costume
 of Tamara Toumanova, the flower worn in 'La Spectre de la
 Rose.' " Typed on exterior lid: "Little Mysteries of the Ballet/
 Into a souvenir-case guarding its sealed treasure of costume
 fragments from 'La Spectre de la Rose'—how explain the
 intrusion of bejewelled and faded tokens of a ballerina of an
 earlier day, accented with a renegade blonde hairpin loosed
 from the chevelure of some Cinderella in her midnight
 haste Reward."
Collection the Estate of Joseph Cornell, Courtesy Castelli/
 Corcoran/Feigen.

57. *Homage to the Romantic Ballet.* 1941.
Construction, 2 × 4¾ × 3½″.
Typed inscription on inside lid reads: "Dream fragments
 loosened by the breezes from the floating form of the fairy,
 Carlotta Grisi. Gold rain shed from garments of the dark fairy,
 Tamara Toumanova in the 'Nutcracker Suite.' "
Collection Mr. and Mrs. Edwin A. Bergman, Chicago.

58. *Mémoires Inédits de Madame la Comtesse de G.* c. 1939.
Construction, 1⁷⁄₈ × 4¼″ diam.
Interior, sealed with glass, contains sand, a ball, a ribbon, and
 loose strips printed with sentence fragments in French—all
 of which are rearranged when the box is shaken. Inscribed
 in print on the lid exterior: "Mémoires inédits de Madame la
 Comtesse de G[enlis—over the omitted letters of the name a
 strip bearing the words 'Rose, servante' in smaller type is
 pasted upside down] sur le dix-huitième siècle et la Révolution
 françoise, depuis 1756 jusqu'à nos jours." Lid interior is lined
 with a letter "AUGUSTE A EUGÈNE" excised from a French
 book. Printed inscription on bottom of box reads: "A Paris,
 chez ladvocat, Libraire de S.A.R. Monseigneur le duc de
 Chartres au Palais-Royal M.DCCC.XXV."
Collection the Estate of Joseph Cornell, Courtesy Castelli/
 Corcoran/Feigen.

59. *Homage to the Romantic Ballet* [*Rosita Mauri's Revenge*].
 1941.
Construction, 1 × 3″ diam.
Typed inscription on inside lid reads: "Rosita Mauri's Revenge /
 On seeing the Tsar in his box, chatting instead of watching
 her dancing, she grumbled: 'Well, I shall certainly not eat
 any more caviar!' / Hommage to the / Romantic Ballet /
 Joseph Cornell / quoted from Cyril Beaumont / 1941."
Collection Mr. and Mrs. Edwin A. Bergman, Chicago.

60. *Mémoires de Madame la Marquise de la Rochejaquelein.* 1943.
Construction, 1⁷⁄₈ × 4¼″ diam.
Interior, sealed with glass, contains sand, rhinestone chips,
 and sentence fragments from a French book glued on movable
 glass strips. Inscription pasted on lid exterior gives title,
 followed by: "Edition, ornée du Portrait de l'Auteur. Paris

1857." A print of a woman knitting is pasted in the lid in-
 terior.
Collection François de Menil, New York.

61. *Object.* 1940.
8⁷⁄₈ × 5⁷⁄₈ × 1½″.
Book construction, with coil and glass inserted into a copy of
 Bibliothèque du médecin-praticien, vol. 12: *Maladies respira-
 toire et circulatoire* (Paris, 1850).
Collection the Estate of Joseph Cornell, Courtesy Castelli/
 Corcoran/Feigen.

62. *Beehive.* 1940–48.
Construction, 3¼ × 7½″ diam.
Collection Richard L. Feigen, New York.

63. *Untitled* [*The Life of Ludwig II of Bavaria*]. c. 1941–52.
Construction, 3⁵⁄₈ × 14½ × 11″.
Hinged box contains material relating to Ludwig II of Bavaria
 and to swans. Ludwig material includes a published biog-
 raphy, photographs and reproductions of Ludwig and the
 places he lived, and a large photograph of a state carriage
 (inside lid). The swan motif appears in small glass sculptures,
 Macy's advertisements, and an empty box labeled "Swan Bill
 Hooks and Eyes." Other material includes a lock of hair,
 a hatpin labeled "private garden fetes, etc. for Richard
 Wagner," and clippings from the *Christian Science Monitor*
 from 1941 to 1952.
Collection the Estate of Joseph Cornell, Courtesy Castelli/
 Corcoran/Feigen.

64. *Taglioni's Jewel Casket.* 1940.
Construction, 4¾ × 11⁷⁄₈ × 8¼″.
Museum of Modern Art, New York (Gift of James Thrall Soby).

65. *Story without a Name—for Max Ernst.*
Collage, 13 × 19″.
Published in *View* magazine, April 1942 (p. 23).
Private Collection.

66. *Pharmacy.* 1942.
Construction, 14 × 12 × 4¾″.
Collection Peggy Guggenheim Foundation, Venice.

67. *Hôtel de l'Ange.* 1944.
Construction, 20 × 14 × 4⅛″.
Collection Peggy Guggenheim Foundation, Venice.

68. *Untitled* [*Sandbox*]. c. 1940.
Construction, 10¾ × 4½ × 2⁷⁄₈″.
Collection Richard L. Feigen, New York.

69. *Naples.* 1942.
Construction, 11¼ × 6¾ × 4¾″.
Collection Mr. and Mrs. Philip Gersh, Beverly Hills, California.

70. *Parrot Music Box.* 1945.
Construction, 16 × 9 × 6⁵⁄₈″.
Collection Peggy Guggenheim Foundation, Venice.

71. *For Stephanie.* c. 1945.
Construction, 19¼ × 14¼ × 5″.
Australian National Gallery, Canberra.

72. *Penny Arcade for Lauren Bacall.* 1946.
Construction, 20½ × 15¾ × 3½″.
Collection Mr. and Mrs. Edwin A. Bergman, Chicago.

73. *Soap Bubble Set.* 1942.
Construction, 15¾ × 18⅜ × 2⅝″.
Collection Peggy Guggenheim Foundation, Venice.

74. *Music Box.* c. 1947.
Construction, 3½ × 7½ × 3½″.
Collection Mr. and Mrs. Edwin A. Bergman, Chicago.

75. *Untitled [Star-Game].* c. 1948.
Construction, 2⅝(h.) × 12¾″ (point to point).
Collection François de Menil, New York.

76. *Nouveaux Contes de Fées (Poison Box).* c. 1948.
Construction, 12⅝ × 10¼ × 5⅞″.
Collection Mr. and Mrs. Edwin A. Bergman, Chicago.

77. *Multiple Cubes.* 1946–48.
Construction, 14 × 10⅜ × 2¼″.
Collection Mr. and Mrs. Edwin A. Bergman, Chicago.

78. *Deserted Perch.* 1949.
Construction, 16½ × 13 × 4″.
Collection Jeanne Reynal, New York.

79. *Untitled [Windows].* c. 1950.
Construction, 17 × 11 × 4½″.
Courtesy ACA Gallery, New York.

80. *Observatory.* 1950.
Construction, 18 × 11⅞ × 5½″.
Movable panel can be adjusted to reveal a painted night sky (as
 illustrated) or a printed astronomical map.
Collection Mr. and Mrs. Edwin A. Bergman, Chicago.

81. *Central Park Carrousel—1950, In Memoriam.* 1950.
Construction, 20¼ × 14½ × 6¾″.
Museum of Modern Art, New York (Katherine Cornell Fund).

82. *Blue Sandbox.* 1959.
Construction, 14⅞ × 8⅝ × 1⅝″.
Collection Albert L. Arenberg, Highland Park, Illinois.

83. *Surrealist Box.* 1951.
Construction, 10¼ × 7⅛ × 2½″.
Art Institute of Chicago (Gift of Frank B. Hubachek).

84. *Chocolat Menier.* 1952.
Construction, 17 × 12 × 4¾″.
Grey Art Gallery and Study Center, New York University.

85. *Dovecote.* 1952.
Construction, 16⅞ × 11¾ × 3⅜″.
Collection Mrs. R. B. Schulhof, New York.

86. *Soap Bubble Set.* 1953.
Construction, 13½ × 19 × 3″.
Art Institute of Chicago (Simeon B. Williams Fund).

87. *Carrousel.* 1952.
Construction, 19½ × 13 × 6″.
Collection Mr. and Mrs. Morton G. Neumann, Chicago.

88. *Juan Gris.* 1954.
Construction, 18½ × 12½ × 4¾″.
Courtesy of Cordier and Ekstrom, New York.

89. *Night Skies: Auriga.* 1954.
Construction, 19¼ × 13½ × 7½″.
Collection Mr. and Mrs. Edwin A. Bergman, Chicago.

90. *Orion.* 1955.
Construction, 18⅝ × 12⅞ × 4¼″.
Collection Albert L. Arenberg, Highland Park, Illinois.

91. *Dien Bien Phu.* 1954.
Construction, 18 × 12 × 6″.
Private Collection, New York.

92. *Untitled [Flemish Princess].* Early 1950s.
Construction, 17 × 10 × 2½″.
Repeated image is a reproduction of J. Piel's *Mlle de Moulins*
 (fifteenth century).
Courtesy ACA Gallery, New York.

93. *Sand Fountain.* Late 1950s.
Construction, 10¾ × 7⅞ × 3½″.
Hirshhorn Museum and Sculpture Garden, Smithsonian Insti-
 tution, Washington, D.C.

94. *Suite de la Longitude.* c. 1957.
Construction, 13½ × 19¾ × 4½″.
Hirshhorn Museum and Sculpture Garden, Smithsonian Insti-
 tution, Washington, D.C.

95. *Space Object Box.* Late 1950s.
Construction, 11⅟₁₆ × 17⅝ × 5⅜″.
Solomon R. Guggenheim Museum, New York.

96. *L'Abeille (Pour Jacques Brel le Magnifique).* 1966.
Collage, 10½ × 13½″.
Collection Mr. and Mrs. Edwin A. Bergman, Chicago.

97. *Mica Magritte II.* c. 1965.
Collage with pencil, 12 × 9″.
Collection Edwin Janss, Jr., Thousand Oaks, California.

98. *The Rescue of Perseus by Andromeda.* Late 1950s–1960s.
Collage, 16⅝ × 12¾″.
Courtesy Castelli/Corcoran/Feigen.

99. *André Breton.* 1966.
Collage, 11¼ × 8¼″.
Collage employs Man Ray photograph of Breton.
Present whereabouts unknown.

100. *Couleur de Pêche.* 1967.
Collage, 12 × 9″.
Private Collection, New York.

BIBLIOGRAPHY

The Joseph Cornell Papers, The Archives of American Art, New York. The papers have been donated to the Archives by Cornell's family and are currently being microfilmed and catalogued. They are not yet open for public inspection.

Dore Ashton, *A Joseph Cornell Album* (New York: Viking, 1974).

Articles and Reviews

H. D., "Here, There, Elsewhere," *The New York Times*, Dec. 10, 1939, Section X, p. 12.

"Playful Objects," *The New York Herald Tribune*, Dec. 10, 1939, Section VI, p. 8.

"Old Prom Programs, Etc.?" *Art Digest*, 14:6 (Dec. 15, 1939), p. 13.

J. L., "Joseph Cornell's Concoctions From the Unconscious," *Art News*, 38:12 (Dec. 23, 1939), p. 8.

Clement Greenberg, "Joseph Cornell and Laurence Vail," *The Nation*, Dec. 26, 1942, pp. 727–728; reprinted in part in the catalogue *Laurence Vail* (New York: Noah Goldowsky, Jan. 2–31, 1974).

E. Boyd, "Art," *Arts and Architecture*, 65:12 (Dec. 1948), p. 12.

Belle Krasne, "Listen to the Mock Birds," *Art Digest*, 24:6 (Dec. 15, 1949), p. 22.

Thomas B. Hess, "Joseph Cornell," *Art News*, 48:1 (Jan. 1950), p. 45.

Belle Krasne, "Cornell Collages," *Art Digest*, 25:6 (Dec. 15, 1950), p. 17.

Henry McBride, "Joseph Cornell maquettes," *Art News*, 49:1 (Jan. 1951), p. 50.

Sidney Geist, "Joseph Cornell," *Art Digest*, 29:12 (March 15, 1953), p. 18.

Fairfield Porter, "Joseph Cornell," *Art News*, 52:3 (April 1953), p. 40.

Allen S. Weller, "Chicago: Joseph Cornell," *Art Digest*, 27:14 (April 15, 1953), pp. 13–14.

Belle Krasne, "Artists in the Margin: Joseph Cornell," *Design Quarterly*, no. 30 (1954), pp. 9, 12.

Al Newbill, "Cornell and Lewitin," *Arts Digest*, 29:19 (Aug. 1, 1955), p. 29.

Frank O'Hara, "Joseph Cornell and Lewitin," *Art News*, 54:5 (Sept. 1955), p. 50.

Laverne George, "Joseph Cornell," *Arts*, 30:4 (Jan. 1956), p. 50.

Henry LaFarge, "Joseph Cornell," *Art News*, 55:1 (March 1956), p. 51.

Lawrence Campbell, "Joseph Cornell," *Art News*, 55:7 (Nov. 1956), p. 6.

Howard Griffin, "Auriga, Andromeda, Cameoleopardalis," *Art News*, 56:8 (Dec. 1957), pp. 24–27, 63–65.

Parker Tyler, "Joseph Cornell," *Art News*, 56:9 (Jan. 1958), pp. 18–19.

E. C. Goossen, "The Plastic Poetry of Joseph Cornell," *Art International*, 3:10 (1959–60), pp. 37–40.

Barbara Butler, "New York Fall 1961," *Quadrum XII* (1961), pp. 135–136.

Dore Ashton, "Art USA 1962," *Studio*, 163:826 (Feb. 1962), p. 94.

Gerald Nordland, "Los Angeles Letter," *Kunstwerk*, 16:5–6 (Nov.–Dec. 1962), p. 67.

John Coplans, "Notes on the Nature of Joseph Cornell," *Artforum*, 1:8 (Feb. 1963), pp. 27–29.

Thomas B. Hess, "The Steel Mistletoe: Generalizations on the relationships between modern American sculpture and painting based on the Whitney's exhibition of 110 sculptures," *Art News*, 61:10 (Feb. 1963), pp. 46–47, 55–57.

Dore Ashton, "New York Letter," *Kunstwerk*, 16:10 (April 1963), p. 32.

Walter Hopps, "Boxes," *Art International*, 8:2 (March 1964), pp. 38–41.

Edward B. Henning, "The Language of Art," *Bulletin of the Cleveland Museum of Art*, 51:9 (Nov. 1964), pp. 219–221.

Vivien Raynor, "Joseph Cornell, Willem de Kooning," *Arts Magazine*, 39:6 (March 1965), p. 53.

Diane Waldman, "Cornell: The compass of boxing," *Art News*, 64:1 (March 1965), pp. 42–45, 49–50.

Ellen H. Johnson, "Arcadia Enclosed: The Boxes of Joseph Cornell," *Arts Magazine*, 39:10 (Sept.–Oct. 1965), pp. 35–37.

Thomas B. Hess, "Eccentric Propositions," *Art News Annual*, 32 (1966), p. 21.

Hilton Kramer, "The Enigmatic Collages of Joseph Cornell," *The New York Times*, Section II, Jan. 23, 1966, p. 15.

Ellen H. Johnson, "A Loan Exhibition of Cornell Boxes," *Allen Memorial Art Museum Bulletin*, Oberlin College, no. 23 (Spring 1966), pp. 127–131.

Fairfield Porter, "Joseph Cornell," *Art and Literature*, no. 8 (Spring 1966), pp. 120–130.

Alexandra Cortesi, "Joseph Cornell," *Artforum*, 4:8 (April 1966), pp. 27–31.

Dore Ashton, "The 'anti-compositional attitude' in sculpture: New York commentary," *Studio International*, 172:879 (July 1966), p. 46.

"The Compulsive Cabinetmaker," *Time*, 88:2 (July 8, 1966), pp. 56–57.

Michael Benedikt, "New York Letter," *Art International*, 10:8 (Oct. 20, 1966) p. 55.

Philip Leider, "Cornell: Extravagant Liberties Within Circumscribed Aims," *The New York Times*, Section II, Jan. 15, 1967, p. 29.

Frank O'Hara, "Joseph Cornell," *Art and Literature*, no. 12 (Spring 1967), p. 71.

Gordon Brown, "A Visit with Joseph Cornell," *Arts Magazine*, 41:7 (May 1967), p. 51.

Lucas Samaras, "Cornell Size," *Arts Magazine*, 41:7 (May 1967), pp. 45–47.

Hilton Kramer, "The Poetic Shadow-Box World of Joseph Cornell," *The New York Times*, May 6, 1967, p. 27.

Christopher Andreae, "Cornell's bird cages and slot machines," *Christian Science Monitor*, May 10, 1967, p. 6.

Max Kozloff, "Art," *The Nation*, 204:22 (May 29, 1967), pp. 701–702.

Harold Rosenberg, "Object Poems," *The New Yorker*, 43:15 (June 3, 1967), pp. 112, 114–118; also collected in the author's *Artworks and Packages*, New York, Horizon Press (1969), pp. 75–87.

Jack Kroll, "Paradise Regained," *Newsweek*, 69:23 (June 5, 1967), p. 86.

John Ashbery, "Cornell: The Cube Root of Dreams," *Art News*, 66:4 (Summer 1967), pp. 56–59, 63–64.

M[el] B[ochner], "Joseph Cornell," *Arts Magazine*, 41:8 (Summer 1967), pp. 53–54.

Lil Picard, "Joseph Cornell (Solomon Guggenheim Museum)," *Kunstwerk*, 20:9–10 (June–July 1967), p. 63.

Ralph Pomeroy, "New York: Torrents of Spring," *Art and Artists*, 2:4 (July 1967), p. 42.

Joseph T. Butler, "The Connoisseur in America: Joseph Cornell at the Guggenheim," *Connoisseur*, vol. 166 (Sept. 1967), p. 64.

David Bourdon, "Enigmatic Bachelor of Utopia Parkway: Boxed Art of Joseph Cornell," *Life*, 163:24 (Dec. 15, 1967), pp. 52–66.

"American Academy Gives Award to Box Sculptor," *New York Post*, Feb. 23, 1968.

"Art Academy Honor to Joseph Cornell," *The New York Times*, Feb. 24, 1968, p. 22.

Hilton Kramer, "New York Notes: The Secret History of Dada and Surrealism," *Art in America*, 56:2 (March–April 1968), pp. 108–112.

Jerrold Lanes, "Exhibition at the Rose Art Museum," *Burlington Magazine*, 110:784 (July 1968), p. 425.

H[ope] F[riedland], "Joseph Cornell," *Arts Magazine*, 43:1 (Sept.–Oct. 1968), p. 58.

Julien Levy, "J. C. of Utopia Parkway," *Juillard* (Winter 1968–69), pp. 29–33.

Knute Stiles, "Untitled '68': The San Francisco Annual Becomes an Invitational," *Artforum*, 7:5 (Jan. 1969), pp. 50–51.

Pierre Courthion, "Situation de la nouvelle peinture américaine," *XXᵉ Siècle*, no. 34 (June 1970), pp. 9–17.

Carter Ratcliff, "New York Letter," *Art International*, 14:7 (Sept. 20, 1970), p. 90.

Alain Jouffroy, "Les Hôtels de Joseph Cornell," *Opus International*, nos. 19–20 (Oct. 1970), pp. 52–56.

Henry Geldzahler, "Collage by Joseph Cornell," *Metropolitan Museum of Art Bulletin*, 29:4 (Dec. 1970), p. 192.

Hilton Kramer, "Surrealism and Collages," *The New York Times*, Dec. 12, 1970, p. 27.

Hilton Kramer, "Joseph Cornell's Baudelairean 'Voyage,'" *The New York Times*, Section II, Dec. 20, 1970, p. 27.

Lawrence Alloway, "Art," *The Nation*, 211:22 (Dec. 28, 1970), pp. 700–701.

Stephen Spector, "Joseph Cornell at the Metropolitan Museum of Art," *Arts Magazine*, 45:3 (Dec. 1970/Jan. 1971), p. 53.

Alexandra C. Anderson, "How to Make a Rainbow," *Art News*, 69:10 (Feb. 1971), pp. 50–52, 72–73.

Gerrit Henry, "New York Letter," *Art International*, 15:3 (March 20, 1971), p. 53.

J. Patrice Marandel, "Lettre de New York," *Art International*, 15:3 (March 20, 1971), pp. 54–55.

"Small Packages: The Metropolitan," *Apollo*, 93:11 (May 1971), p. 432.

Carter Ratcliff, "New York Letter: Collage," *Art International*, 15:8 (Oct. 20, 1971), p. 58.

"Mostre: Torino, Joseph Cornell," *Domus*, no. 504 (Nov. 11, 1971), p. 51.

Diana Loercher, "Interview with Cornell at Cooper Union," *Christian Science Monitor*, (Feb. 1972).

William D. Case, "In the Galleries: Joseph Cornell," *Arts Magazine*, 46:4 (Feb. 1972), p. 59.

Deborah Dorsey, "Reviews and Previews: Joseph Cornell," *Art News*, 70:10 (Feb. 1972), p. 13.

Grace Glueck, "Youths Laud Cooper Union 'Adult' Art," *The New York Times*, Feb. 11, 1972, p. 22.

Arthur Secunda, "In the Galleries: Joseph Cornell," *Arts Magazine*, 46:5 (March 1972), p. 60.

"Exhibition: Cooper Union," *College Art Journal*, 31:4 (Summer 1972), p. 442.

Bernhard Kerber, "Documenta und Szene Rhein-Ruhr," *Art International*, 16:8 (Oct. 1972), p. 68.

"Joseph Cornell, Sculptor, Dies; Noted for His Work With Boxes," *The New York Times*, Dec. 31, 1972, p. 37.

John Loring, "Phoenix House Portfolio," *Arts Magazine*, 47:3 (Dec. 1972–Jan. 1973), pp. 70–71.

Peter Winter, "Henri Michaux und Joseph Cornell," *Kunstwerk*, 26:1 (Jan. 1973), p. 74.

Jonas Mekas and Donald Windham, "Joseph Cornell, December 24, 1903–December 29, 1972," *The Village Voice*, Jan. 11, 1973, p. 26.

Diane Waldman, "Joseph Cornell, 1903–1972," *Art News*, 72:2 (Feb. 1973), pp. 56–57.

Marilyn Bethany, "Joseph Cornell: December 24, 1903–December 29, 1972," *Saturday Review of the Arts*, 1:2 (Feb. 3, 1973), p. 58.

D[ouglas] D[avis], "Living in Utopia," *Newsweek*, 81:6 (Feb. 5, 1973), p. 63.

Hilton Kramer, "Collage Show Honors Joseph Cornell," *The New York Times*, March 21, 1973, p. 52.

Sanford Schwartz, "New York Letter," *Art International*, 17:4 (April 1973), p. 49.

McCandlish Phillips, "The Portrait of Queens Artist," *The New York Times*, April 15, 1973, pp. 71, 74.

Daniel Abadie, "Deux alchimistes du quotidien: Joseph Cornell et Louise Nevelson," *XXᵉ Siècle*, no. 40 (June 1973), pp. 104–109.

Paul Hammond, "Fragments of the Marvellous," *Art and Artists*, 8:4 (July 1973), pp. 28–33.

John Bernard Myers, "Cornell: The Enchanted Wanderer," *Art in America*, 61:5 (Sept.–Oct. 1973), pp. 76–81.

L. J. Miller, "Creativity in Boxes," *Design*, vol. 75 (Winter 1973), pp. 20–21.

Henri Coulonges, "Cornell et ses oeuvres fragiles connaissent subitement une faveur grandissante," *Connaissance des arts*, no. 262 (Dec. 1973), pp. 126–131.

Lawrence Alloway, "The View from the 20th Century," *Artforum*, 12:5 (Jan. 1974), p. 43.

Michael Kernan, "Visions From the Utopia Parkway," *Washington Post*, Jan. 2, 1974, pp. D1, D8.

Joseph T. Butler, "The American Way with Art: The Art of Visual Metaphors: Joseph Cornell," *Connoisseur*, vol. 185 (April 1974), p. 305.

Brian O'Doherty, "Cornell: Disappearing Act," *The New York Post*, Aug. 17, 1974, p. 32.

Howard Hussey, "Joseph Cornell (Towards a Memoir)," *Prose*, no. 9 (Fall 1974), pp. 73–85.

"Homage to Joseph Cornell," *Craft Horizons*, 34:5 (Oct. 1974), pp. 38–40.

Melinda Wortz, "Los Angeles: High Hopes," *Art News*, 73:8 (Oct. 1974), p. 87.

Hilton Kramer, "A Joseph Cornell Album," *The New York Times Book Review*, Dec. 29, 1974, pp. 1–2.

Joseph Dreiss, "Arts Reviews: Group Show," *Arts Magazine*, 49:6 (Feb. 1975), p. 17.

Donald Windham, (letter to the editor, column heading, "Joseph Cornell"), *The New York Times Book Review*, Feb. 2, 1975, p. 28.

Joseph Dreiss, "Arts Reviews: Group Show," *Arts Magazine*, 49:7 (March 1975), p. 18.

John Bernard Myers, "Joseph Cornell: 'It was his genius to imply the cosmos,' " *Art News*, 74:5 (May 1975), pp. 33–36.

John Russell, "Art: Guimet's Rarities Evoke the Orient of Old," *The New York Times*, May 17, 1975, p. 14.

Hilton Kramer, "Cornell's Innocent World," *The New York Times*, Section II, May 18, 1975, p. 35.

Katharine Kuh, "Joseph Cornell: In Pursuit of Poetry," *Saturday Review*, vol. 2 (Sept. 6, 1975), pp. 37–39.

Jane H. Kay, "A Dreamer and His Boxes," *Christian Science Monitor*, Oct. 29, 1975, p. 24.

John Bernard Myers, "Joseph Cornell, and The Outside World," *College Art Journal*, 35:2 (Winter 1975/76), pp. 115–117.

"Excerpts from Howard Hussey's Memoirs of Joseph Cornell (1966–1972)," *Parenthèse*, no. 3 (1976), pp. 153–158.

John Russell, "Worlds of Boxes, Packages and Columns," *The New York Times*, March 14, 1976, Section II, pp. 29–30.

Douglas Davis and Mary Rourke, "Souvenirs," *Newsweek*, 87:9 (March 1, 1976), p. 81.

Robert Hughes, "The Last Symbolist Poet," *Time*, 107:10 (March 8, 1976), pp. 66–67.

Sandy Ballatore, "Joseph Cornell's Collages," *Art Week*, 7:13 (March 27, 1976), pp. 1, 16.

Noel Frackman, "Joseph Cornell," *Arts Magazine*, 50:9 (May 1976), p. 5.

Martha McWilliams Wright, "A Glimpse at the Universe of Joseph Cornell," *Arts Magazine*, 51:2 (Oct. 1976), pp. 118–121.

General

André Breton, *Le Surréalisme et la peinture* (Paris, 1928); enlarged version of material that appeared originally in *La Révolution Surréaliste*, 1:4 (July 15, 1925), pp. 26–30; 2:6 (March 1, 1926), pp. 30–32; and 3:9–10 (Oct. 1, 1927), pp. 36–43. *Surrealism and Painting*, translated by Simon Watson Taylor (New York: Harper & Row, Icon Editions, 1972).

André Breton, *Qu'est-ce que le Surréalisme?* (Brussels: René Henriquez, 1934); *What is Surrealism?*, translated by David Gascoyne (London: Faber and Faber, 1936).

Alfred H. Barr, Jr., *Fantastic Art, Dada, Surrealism* (New York, 1936; enlarged editions with essays by Georges Hugnet: New York, 1937, 1947).

Julien Levy, *Surrealism* (New York: Black Sun Press, 1936; reprinted New York: Arno/Worldwide, 1968).

Dictionnaire Abrégé du Surréalisme (Paris: Galerie Beaux-Arts, 1938); includes the catalogue for the *Exposition International du Surréalisme* held at the Galerie Beaux-Arts, January-February 1938.

Sidney Janis, *Abstract and Surrealist Art in America* (New York: Reynal & Hitchcock, 1944), pp. 86, 88, 106.

John I. H. Baur, *Revolution and Tradition in Modern American Art* (Cambridge: Harvard University Press, 1951), p. 31.

Rudi Blesh, *Modern Art USA* (New York: Knopf, 1956), pp. 176, 215, 244.

Hugh Edwards (ed.), *Surrealism and Its Affinities: The Mary Reynolds Collection* (Chicago: Art Institute of Chicago, 1956), pp. 26–27; reprint (1973), p. 30.

Sam Hunter, *Modern American Painting and Sculpture* (New York: Dell, 1959), pp. 183–184.

Michel Seuphor, *La sculpture de ce siècle: Dictionnaire de la sculpture moderne* (Neuchâtel: Editions du Griffon, 1959), pp. 252–253.

Robert Goldwater, "Joseph Cornell," *Dictionary of Modern Sculpture*, edited by Robert Maillard (New York: Tudor, 1960), pp. 64–65; rev. ed., *New Dictionary of Modern Sculpture* (1971), pp. 71–72.

Marcel Jean and Arpad Mezei, *The History of Surrealist Painting*, translated by S. W. Taylor (New York: Grove Press, 1960), pp. 260, 273, 289, 307, 313–317, 349, 350; originally published as *Histoire de la Peinture Surréaliste* (Paris: Editions de Seuil, 1959).

Harriet Janis and Rudi Blesh, *Collage: Personalities Concepts Techniques* (New York: Chilton, 1962), pp. 86–87, 253.

Metro International Directory of Contemporary Art (Milan: Metro, 1964), pp. 86–87.

Herbert Read, *A Concise History of Modern Sculpture* (New York: Praeger, 1964), p. 264.

Harold Rosenberg, *The Anxious Object: Art Today and its Audience* (New York: Horizon, 1964), p. 64.

Elena and Nicolas Calas, *The Peggy Guggenheim Collection of Modern Art* (New York: Abrams, 1966), pp. 122–123.

Samuel M. Green, *American Art: A Historical Survey* (New York: Ronald Press, 1966), pp. 611, 643.

Will Grohman (ed.), *New Art Around the World: Painting and Sculpture* (New York: Abrams, 1966), pp. 31, 45, 85.

Christopher Finch, *Pop Art: Object and Image* (New York: Dutton, 1968), pp. 36–37.

Max Kozloff, *Renderings: Critical Essays on a Century of Modern Art* (New York: Simon and Schuster, 1968), pp. 153–158, 204.

Herta Wescher, *Die Collage: Geschichte eines kunstlerischen Ausdrucksmittels* (Cologne: DuMont Schauberg, 1968), p. 249; translated by Robert E. Wolf, *Collage* (New York: Abrams, 1968), pp. 250–251.

Henry Geldzahler, *New York Paintings and Sculpture: 1940–1970* (New York: E. P. Dutton and The Metropolitan Museum of Art, 1969), pp. 31, 42–43, 431–432, 457.

William S. Rubin, *Dada and Surrealist Art* (New York: Abrams, 1969), pp. 266, 468.

Paul Cummings, *A Dictionary of Contemporary American Artists* (New York: St. Martin's, 1971), pp. 100–101.

Dore Ashton, "Cornell, Joseph (1903–73)," *Britannica Encyclopedia of American Art* (New York: Simon and Schuster, Chanticleer Press Edition, 1973), pp. 124–126.

Brian O'Doherty, *American Masters: The Voice and the Myth* (New York: Random House, A Ridge Press Book, 1973), pp. 254–283.

Sam Hunter, *American Art of the Twentieth-Century: Painting Sculpture Architecture*, rev. ed. (New York: Abrams, 1974), pp. 295, 331, 421.

Alex Mogelon and Norman Laliberté, *Art in Boxes* (New York: Van Nostrand Reinhold, 1974), pp. 76–84.

Barbara Rose, *American Art Since* 1900, rev. ed. (New York: Praeger, 1975), pp. 178, 265–266.

By the Artist: Published Designs and Articles

"Monsieur Phot (Scenario)," in Julien Levy, *Surrealism* (New York: Black Sun Press, 1936), pp. 77–88. Also cover design for same. Reprinted New York: Arno/Worldwide Press, 1968. An original typescript of "Monsieur Phot (seen through the stereoscope)" exists in the Mary Reynolds Collection, The Art Institute of Chicago.

Cover design, Charles Henri Ford, *ABC's for the children of no one, who grows up to look like everyone's son* (Prairie City, Ill.: James A. Decker Press, 1940).

"Enchanted Wanderer: Excerpt from a Journey Album for Hedy Lamarr," *View*, Series I, nos. 9–10 (Dec. 1941–Jan. 1942), p. 3.

"Story Without a Name—For Max Ernst," *View*, Series II, no. 1 (April 1942), p. 23.

"Americana Fantastica," cover of *View*, Series II, no. 4 (Jan. 1943). This issue also includes "The Crystal Cage (Portrait of Berenice)," pp. 10–16 and "…like a net of stars…," pp. 36–38. See also pp. 21, 23.

"¾ Birds-Eye View of a Watch-Case for Marcel Duchamp," collage illustration, *View*, Series V, no. 1 (March 1945), p. 22.

"Hommage à Isadora," cover montage, *Dance Index*, 1:1 (Jan. 1942).

"The Parker Sisters," cover montage, *Dance Index*, 1:2 (Feb. 1942).

"Loie Fuller," cover montage, *Dance Index*, 1:3 (March 1942).

Chart cover, *Dance Index*, 1:6 (June 1942).

"Elssler Quadrilles," cover, *Dance Index*, 1:12 (Dec. 1942).

"Portrait of Allen Dodworth (1847)," montage cover, *Dance Index*, 2:4 (April 1943).

Cover montage, *Dance Index*, 3:4–6 (April–May–June, 1944).

"Fanny Cerrito" (pp. 121–125) and throughout, including cover, "Le Quatuor Dansé à Londres par Taglioni, Carlotta Grisi, Cerrito et Fanny Elsler [sic]," *Dance Index*, 3:7–8 (July–Aug. 1944).

"Three or Four Graces," cover frame, *Dance Index*, 3:9–11 (Sept.–Oct.–Nov. 1944).

Cover, *Dance Index*, 4:5 (May 1945).

"Annetta Galletti, Louise Lamoureux, Ermesilda Diana, Kate Penoyer, Joseph De Rosa," cover, *Dance Index*, 4:6–8 (June–July–Aug. 1945).

"Comment," and "Theatre of Hans Christian Andersen" (a scenario), *Dance Index*, 4:9 (Sept. 1945), pp. 139, 155–159. The front and back covers of this issue were selected by Cornell from Andersen's work.

"Around a scene from Sadler Wells' 1943 revival of The Swan Lake," cover arrangement, *Dance Index*, 4:10 (Oct. 1945).

"Clowns, Elephants and Ballerinas," cover, *Dance Index*, 5:6 (June 1946).

"Americana Romantic Ballet" (cover) and "Comment" (p. 203), *Dance Index*, 6:9 (Sept. 1947). Material throughout compiled and arranged by Cornell.

"Make It From A Pattern For Your Dream-Child," a collage story on Simplicity patterns for dolls' clothes (with Ernst Beadle), *Harper's Bazaar*, Dec. 1947, pp. 132–133.

Fashion layout incorporating four shadow boxes, *Mademoiselle*, March 1944, pp. 130–131.

Collage of Newport for the article, "Going, going, gone," by Leo Lerman, *Mademoiselle*, July 1950, pp. 70–71.

"Bank of True Love," valentine taken from the collection of Joseph Cornell, *Mademoiselle*, Feb. 1957, p. 103.

Maria (1954) and *The Bel Canto Pet* (1955), booklets published privately by Cornell, using texts by Elise Polko and Nathanial Parker Willis. Collage inserts vary in individual copies of both booklets, which the artist signed and dated according to the year he sent them to friends.

"Constellation," Christmas card designed for the Museum of Modern Art, New York, 1954.

Cover, *Juillard*, Winter 1968–69.

On Cornell's Films

Julien Levy, *Surrealism* (New York: Black Sun Press, 1936), pp. 77–88.

Hugh Edwards (ed.), *Surrealism and Its Affinities: The Mary Reynolds Collection* (Chicago: Art Institute of Chicago, 1956), p. 26. Revised edition with additional material (1973), p. 30.

Jonas Mekas, "Joseph Cornell, The Poet of the Unpretentious," *The Village Voice*, December 5, 1963. Reprinted in *Movie Journal: The Rise of the New American Cinema 1959–1971* (New York: Collier, 1972), p. 110.

Jonas Mekas, "The Invisible Cathedrals of Joseph Cornell," *The Village Voice*, December 31, 1970, p. 41. Also collected in the author's *Movie Journal* (1972), pp. 407–410, and in Dore Ashton, *A Joseph Cornell Album* (New York: Viking, 1974), pp. 162–167.

Annette Michelson, "Rose Hobart and Monsieur Phot: Early Films from Utopia Parkway," *Artforum* 11:10 (June 1973), pp. 47–57.

P. Adams Sitney, *Visionary Film* (New York: Oxford University Press, 1974), pp. 368–406.

One-Man Exhibitions

Julien Levy Gallery, New York, *Exhibition of Objects (Bilboquet) by Joseph Cornell*, Dec. 6–31, 1939. Text by Parker Tyler.

Julien Levy Gallery, New York, *Joseph Cornell: Exhibition of Objects*, Dec. 10, 1940. Announcement includes "daguerreo-types, miniature glass bells, soap bubble sets, shadow boxes, minutiae, Homage to the Romantic Ballet (Maria Taglioni, Fanny Cerrito, Carlotta Grisi, etc.)."

Wakefield Gallery, New York, an exhibition of children's material arranged by Cornell and including his own work, May 1942.

Ayer Galleries (N. W. Ayer & Son, Inc.), Philadelphia, 1942.

Park Lane Hotel, New York, *From the Dawn of Diamonds Created by Joseph Cornell; An Art exhibit which traces the origins of our oldest bridal traditions*, March 15, 1946; Arthur A. Everts, Dallas, December 1946. An exhibition arranged by N. W. Ayer & Son, Inc., on behalf of their client, De Beers Diamonds, Ltd. Cornell executed twelve electrically lighted

shadow boxes for this exhibition, each showing a different bridal custom and incorporating diamonds lent by Cartier, Inc.

Romantic Museum at the Hugo Gallery, New York, *Portraits of Women: Constructions and Arrangements by Joseph Cornell,* Dec. 3, 1946. Announcement includes three collage inserts of Cornell's *Unknown (the Crystal Cage), Penny Arcade Portrait of Lauren Bacall, Bébé Marie,* and Cornell's descriptive texts on other works.

Copley Galleries, Beverly Hills, *Objects by Joseph Cornell,* Sept. 28, 1948. Announcement, designed by Cornell, contains his descriptive texts on the works exhibited.

Egan Gallery, New York, *Aviary by Joseph Cornell,* Dec. 1949. Text by Donald Windham.

New York Public Library, Central Children's Room, New York, *The Fairy Tale World,* June 5–Nov. 4, 1950; exhibition organized by Maria Cimino. A description of the exhibition can be found in the *Annual Report of Exhibitions in the Central Children's Room,* June 30, 1951.

Egan Gallery, New York, *Night Songs and Other New Work— 1950 by Joseph Cornell,* Dec. 1, 1950–Jan. 13, 1951.

Egan Gallery, New York, *Night Voyage by Joseph Cornell,* Feb. 10–March 10, 1953.

Allan Frumkin Gallery, Chicago, *Joseph Cornell: 10 years of his art,* April 10–May 7, 1953.

Walker Art Center, Minneapolis, *Joseph Cornell,* July 12–Aug. 30, 1953.

Stable Gallery, New York, *Winter Night Skies by Joseph Cornell,* Dec. 12, 1955–Jan. 13, 1956. Announcement includes text submitted by Cornell from Garrett P. Serviss's *Astronomy with an Opera-glass.*

One-Wall Gallery, Wittenborn, New York, *Portrait of Ondine,* Nov. 1–15, 1956.

Stable Gallery, New York, *Joseph Cornell: Selected Works,* Dec. 2–31, 1957.

The New Gallery, Bennington College, Bennington, *Bonitas Solstitialis: Selected Works by Joseph Cornell* and *An Exploration of the Columbier,* Nov. 20–Dec. 15, 1959.

Ferus Gallery, Los Angeles, *Joseph Cornell,* Dec. 10, 1962.

New York University Art Collection, Loeb Student Center, New York, called by Cornell a "Christmas present to the students of New York University," Dec. 3–18, 1963.

J. L. Hudson Gallery, Detroit, *Joseph Cornell,* through Oct. 30, 1965.

Cleveland Museum of Art, Cleveland, *The Boxes of Joseph Cornell,* Nov. 30, 1965–Feb. 27, 1966. Text by Edward B. Henning.

Allan Stone Gallery, New York, *Joseph Cornell,* Feb. 1966.

Robert Schoelkopf Gallery, New York, *Joseph Cornell,* April 26–May 14, 1966.

Pasadena Art Museum, Pasadena, *An Exhibition of Works by Joseph Cornell,* Jan. 9–Feb. 11, 1967. Preface and Acknowledgments by James Demetrion, pp. 7–8; text by Fairfield Porter, pp. 9–13; and an excerpt from a letter by Cornell dated Sept. 16, 1942, p. 15.

Solomon R. Guggenheim Museum, New York, *Joseph Cornell,* May 4–June 25, 1967. Preface by Thomas M. Messer, p. 7; text by Diane Waldman, pp. 11–21.

Poses Institute of Fine Arts, Rose Art Museum, Brandeis University, Waltham, *Boxes and Collages by Joseph Cornell,* May 20–June 23, 1968.

Exhibition Gallery, Queens College, Flushing, *Joseph Cornell,* Nov.–Dec. 1968. Text by Fairfield Porter (excerpt reprinted from *Art and Literature,* no. 8 [Spring 1966]).

Cosmopolitan Club, New York, *Art: Joseph Cornell,* Feb. 16– March 23, 1970.

Metropolitan Museum of Art, New York, *Collage by Joseph Cornell,* Dec. 10, 1970–Jan. 24, 1971.

Galleria Galatea, Turin, *Joseph Cornell,* Oct. 15–Nov. 13, 1971. Text by Luigi Carluccio.

Gimpel and Hanover Galerie, Zurich, *Joseph Cornell: Boxes und Collages,* Jan. 15–Feb. 19, 1972; exhibition arranged by Erica Brausen in collaboration with Daniel Varenne, Paris. Includes texts by Kynaston L. McShine from the Museum of Modern Art catalogue for *The Art of Assemblage* (1961).

Allan Stone Gallery, New York, *Joseph Cornell,* Jan. 29–Feb. 24, 1972.

Cooper Union, New York, a Joseph Cornell exhibition for children, arranged by Dore Ashton for the Department of Art and Architecture, Feb. 10–March 2, 1972.

Albright-Knox Art Gallery, Buffalo, *Joseph Cornell—Collages and Boxes,* April 17–June 5, 1972.

Hopkins Center Art Galleries, Dartmouth College, Hanover, *Joseph Cornell: Collages and Boxes,* Jan. 5–Feb. 28, 1973.

Queens County Art and Cultural Center, Inc., *Homage to Joseph Cornell 1903–1972,* March 18–May 6, 1973. Text by Diane Waldman (reprinted from *Art News,* 72:2 [Feb. 1973], pp. 56–57); preface and acknowledgments by Claire Fisher.

Museum of Contemporary Art, Chicago, *Cornell in Chicago,* Nov. 17, 1973–Jan. 6, 1974. Text by Patricia Stewart.

National Collection of Fine Arts, Smithsonian Institution, Washington, D.C., *Joseph Cornell (1903–1972),* Dec. 23, 1973– June 2, 1974.

Hopkins Center Art Galleries, Dartmouth College, Hanover, *Collages By Joseph Cornell,* April 25–May 5, 1974.

Pyramid Galleries, Washington, D.C., *Joseph Cornell,* April 15– May 19, 1975.

ACA Galleries, New York, *Joseph Cornell,* May 3–31, 1975. Text by John Bernard Myers, pp. 3–15.

Leo Castelli Gallery, New York, in association with Richard L. Feigen & Company, New York, and James Corcoran Gallery, Los Angeles, *Joseph Cornell,* Feb. 28–March 20, 1976. Portfolio-catalogue, *Joseph Cornell Portfolio,* edited by Sandra Leonard Starr, with contributions by Donald Barthelme, Bill Copley, Tony Curtis, Howard Hussey, Allegra Kent, Julien Levy, Jonas Mekas, Robert Motherwell, and Hans Namuth. Motherwell's "Preface to a Joseph Cornell Exhibition" was written for a catalogue that was never published for the Walker Art Center, exhibition of 1953 (see above). Bibliography and catalogue by Sandra Leonard Starr.

James Corcoran Gallery, Los Angeles, in association with Leo Castelli Gallery and Richard L. Feigen & Company, New York, *Joseph Cornell: Collages,* March 4–31, 1976.

John Berggruen Gallery, San Francisco, *Joseph Cornell: Constructions and Collages,* May 12–June 12, 1976.

Group Exhibitions

Julien Levy Gallery, New York, *Surrealism*, Jan. 9–29, 1932. Julien Levy circulated this exhibition to the Wadsworth Atheneum, Hartford, prior to its opening in New York. Catalogue cover designed by Cornell.

Julien Levy Gallery, New York, *Joseph Cornell: Minutiae, Glass Bells, Shadow Boxes, Coups d'Oeil, Jouets Surréalistes*, Nov. 26–Dec. 30, 1932. A two-man exhibition with Picasso etchings.

Julien Levy Gallery, New York, *Objects by Joseph Cornell, Posters by Toulouse-Lautrec, Watercolors by Perkins Harnly, Montages by Harry Brown*, Dec. 12 (announcement gives no year, but the exhibition probably took place in the mid-1930s).

Museum of Modern Art, New York, *Fantastic Art, Dada, Surrealism*, Dec. 9, 1936–Jan. 17, 1937. Text by Alfred H. Barr, Jr. Enlarged edition with essays by Georges Hugnet, 1937.

Galerie Beaux-Arts, Paris, *Exposition Internationale du Surréalisme*, Jan.–Feb. 1938; organized by André Breton and Paul Eluard.

Wadsworth Atheneum, Hartford, *The Painters of Still Life*, Jan. 25–Feb. 15, 1938. Foreword by A. Everett Austin and Henry R. Hitchcock; introduction by "J.R.S." states that Cornell objects were exhibited but not catalogued.

Julien Levy Gallery, New York, *Surrealist Group Show*, Feb. 1940.

Art of this Century, New York, *Objects by Joseph Cornell; Marcel Duchamp: Box-Valise; Laurence Vail: Bottles*, Dec. 1942.

Julien Levy Gallery, *Through The Big End of the Opera Glass: Marcel Duchamp, Yves Tanguy, Joseph Cornell*, Dec. 7, 1943.

San Francisco Museum of Art, San Francisco, *Abstract and Surrealist Art in the United States*, July 1944; Cincinnati Art Museum, Feb. 8–March 12, 1944; Denver Art Museum, March 26–April 23, 1944; Seattle Art Museum, May 7–June 10, 1944; Santa Barbara Museum of Art, June–July 1944. Selected by Sidney Janis; Foreword by "G.L.M.M."; Introduction by Sidney Janis.

Hugo Gallery, New York, *Poetic Theater*, Dec. 19, 1945–Jan. 12, 1946.

California Palace of the Legion of Honor, San Francisco, *Illusionism & Trompe L'Oeil*, May 3–June 12, 1949. Foreword by Thomas Carr Howe, Jr.; texts by Jermayne MacAgy, Alfred Frankenstein, Douglas MacAgy.

Egan Gallery, New York, *New Work by Joseph Cornell*, June 1–24, 1950 (announcement includes other gallery artists).

California Palace of the Legion of Honor, San Francisco, *Time and Man: An Idea Illustrated by an Exhibition*, March 29–May 11, 1952. Texts by Jermayne MacAgy, Irene Lagorio, and Sidney Peterson.

Whitney Museum of American Art, New York, *1953 Annual Exhibition of Contemporary American Sculpture, Watercolors and Drawings*, April 9–May 29, 1953. Cornell was included in the Whitney Annual Exhibitions in 1954 (March 17–April 18); 1955 (Jan. 12–Feb. 20); 1956 (April 18–June 10); 1957 (Nov. 14, 1956–Jan. 6, 1957); 1958 (Nov. 19, 1958–Jan. 4, 1959); 1960 (Dec. 7, 1960–Jan. 22, 1961); 1962 (Dec. 12, 1962–Feb. 3, 1963); 1964 (Dec. 9, 1964–Jan. 31, 1965); 1966 (Dec. 16, 1966–Feb. 5, 1967). Cornell was featured in the 1962 Annual with a separate installation containing 19 works (17 boxes, 2 collages).

Stable Gallery, New York, *Third Annual Exhibition of Painting and Sculpture*, Jan. 27–Feb. 20, 1954.

New York Public Library, Central Children's Room, exhibition in honor of the 150th anniversary of the birth of Hans Christian Andersen, organized jointly by the New York Public Library and the Danish Information Office, April 2–June 1955. A description of the exhibition can be found in the *Annual Report of the Central Children's Room*, June 1955.

Art Institute of Chicago, Chicago, *62nd American Exhibition*, Jan. 17–March 3, 1957. Foreword by Frederick A. Sweet.

Contemporary Arts Museum, Houston, *Recent Contemporary Acquisitions in Houston*, July 25–Aug. 25, 1957. Foreword by Jermayne MacAgy.

Contemporary Arts Museum, Houston, *The Disquieting Muse: Surrealism*, Jan. 9–Feb. 16, 1958. Text by Jermayne MacAgy and Julien Levy.

Contemporary Arts Museum, Houston, *Collage International: From Picasso to the Present*, Feb. 27–April 6, 1958. Text by Jermayne MacAgy.

Department of Fine Arts, Carnegie Institute, Pittsburgh, *Retrospective Exhibition of Paintings from Previous Internationals*, Dec. 5, 1958–Feb. 8, 1959. Foreword by Gordon Bailey Washburn; Introduction by Leon Anthony Arkus; Biographical Notes by Alice Davis.

Time, Inc., New York, *Art and the Found Object*, Jan. 12–Feb. 6, 1959; Williams College, Williamstown, Feb. 22–March 15, 1959; Cranbrook Academy of Art, Bloomfield Hills, April 8–28, 1959; Arts Club of Chicago, Chicago, May 20–June 20, 1959; University of Notre Dame, Notre Dame, July 1–21, 1959; Montreal Museum of Fine Arts, Montreal, Sept. 27–Oct. 18, 1959; Vassar College, Poughkeepsie, Nov. 4–24, 1959; Brandeis University, Waltham, Dec. 15, 1959–Jan. 15, 1960. Organized by the American Federation of the Arts; selected by Roy Moyer.

Contemporary Arts Association of Houston, Houston, *Out of the Ordinary*, Nov. 26–Dec. 27, 1959. Text by Harold Rosenberg.

Art Institute of Chicago, Chicago, *63rd American Exhibition of Painting and Sculpture*, Dec. 2, 1959–Jan. 1960. Selected by Katharine Kuh.

Richard Feigen Gallery, Chicago, *Cornell, Berger, Carloye*, Dec. 17, 1959–Jan. 8, 1960.

D'Arcy Galleries, New York, *Surrealist Intrusion in the Enchanters' Domain*, Nov. 28, 1960–Jan. 14, 1961. Directed by André Breton and Marcel Duchamp; managed by Edouard Jaguer and José Pierre; text translated from the French by Julien Levy and Claude Tarnaud.

Museum of Modern Art, New York, *The Art of Assemblage*, Oct. 2–Nov. 12, 1961; The Dallas Museum for Contemporary Art, Dallas, Jan. 9–Feb. 11, 1962; San Francisco Museum of Art, March 5–April 15, 1962. Foreword, acknowledgments, and text by William C. Seitz; Cornell entry by Kynaston L. McShine.

Dallas Museum for Contemporary Arts, Dallas, *The Art That Broke The Looking-Glass*, Nov. 15–Dec. 31, 1961. Text by Douglas MacAgy.

Rose Fried Gallery, New York, *Modern Masters*, Nov. 20–Dec. 16, 1961.

Seattle World's Fair, Seattle, *Art Since 1950: American and*

International, April 21–Oct. 21, 1962. Foreword by Norman Davis; introduction to the American Section by Sam Hunter. The American section was afterwards exhibited at the Rose Art Museum, Brandeis University, Waltham, and The Institute for Contemporary Arts, Boston, under the title, *American Art Since* 1950. Foreword and introduction by Sam Hunter.

Solomon R. Guggenheim Museum, New York, *Modern Sculpture from the Joseph H. Hirshhorn Collection,* Oct. 3, 1962–Jan. 20, 1963. Foreword by Abram Lerner; text by H. H. Arnason.

Royal Marks Gallery, New York, *Much Has Happened 1910–1959; Key Transitions,* Nov. 25–Dec. 21, 1963. Text by Dore Ashton.

Rose Fried Gallery, New York, *Modern Masters,* Jan. 11–Feb. 15, 1964.

Dwan Gallery, Los Angeles, *Boxes,* Feb. 2–29, 1964. Acknowledgments by John Weber; text by Walter Hopps.

Allan Stone Gallery, New York, *De Kooning/Cornell,* Feb. 13–March 13, 1964.

Art Institute of Chicago, Chicago, *67th Annual American Exhibition,* Feb. 28–April 12, 1964. Note by John Maxon; foreword by A. James Speyer.

Fine Arts Gallery, University of St. Thomas, Houston, *Out of This World: An Exhibition of Fantastic Landscapes From the Renaissance to the Present,* March 20–April 30, 1964. Texts by Dominique de Menil, Etienne Souriau, and Jermayne MacAgy.

Feigen-Palmer Gallery, Los Angeles, *20th Century Masters,* May 3–23, 1964.

Martha Jackson Gallery, New York, *New Acquisitions,* Sept. 18–Oct. 15, 1964.

Musée Rodin, Paris, *États-Unis: sculptures du xxe siècle,* 1965. Texts by Cécile Goldscheider and René d'Harnoncourt.

Allan Stone Gallery, New York, *De Kooning/Cornell,* Feb. 20–March 18, 1965.

Museum of Modern Art, New York, *American Collages,* May 11–July 25, 1965. Directed by Kynaston McShine.

Allan Stone Gallery, New York, *Founding Fathers,* Oct. 26–Nov. 13, 1965.

Richard Feigen Gallery, Chicago, *Poetry in Painting 1931–1949,* from the Collection of the Julien Levy Gallery, New York, Nov. 10–Dec. 18, 1965. Foreword by Julien Levy.

Robert Schoelkopf Gallery, New York, *Robert Cornell: Memorial Exhibition, Drawings by Robert Cornell, Collages by Joseph Cornell, Related Varia,* Jan. 4–29, 1966.

Los Angeles County Museum of Art, *American Sculpture of the Sixties,* April 28–June 25, 1967; Philadelphia Museum of Art, Sept. 15–Oct. 29, 1967. Introduction by Maurice Tuchman; essays by Lawrence Alloway, Wayne V. Andersen, Dore Ashton, John Coplans, Clement Greenberg, Max Kozloff, Lucy R. Lippard, James Monte, Barbara Rose, Irving Sandler.

Sidney Janis Gallery, New York, *Homage to Marilyn Monroe,* Dec. 6–30, 1967.

First Indian Triennial of Contemporary World Art, sponsored by India's National Academy of Art, Feb.–April 1968.

Finch College Museum of Art, *Betty Parsons' Private Collection,* March 13–April 24, 1968; Cranbrook Academy of Art, Bloomfield, Sept. 22–Oct. 20, 1968; Brooks Memorial Art Gallery, Memphis, Nov. 1–Dec. 1, 1968. Foreword by E. C. Goossen.

Museum of Modern Art, New York, *Dada, Surrealism and Their Heritage,* March 27–June 9, 1968; Los Angeles County Museum of Art, July 16–Sept. 8, 1968; Art Institute of Chicago, Oct. 19–Dec. 8, 1968. Text by William S. Rubin.

Galerie an der Schönen Aussicht, Kassel, *Documenta 4,* June 27–Oct. 6, 1968.

University of St. Thomas, Houston, *Jermayne MacAgy: A Life Illustrated by an Exhibition,* Nov. 1968–Jan. 1969. Introduction by Dominique de Menil.

San Francisco Museum of Art, *Untitled 1968,* Nov. 9–Dec. 29, 1968. Foreword by Gerald Nordland; Introduction by Wesley Chamberlain.

Addison Gallery of American Art, Phillips Academy, Andover, *Seven Decades, Seven Alumni of Phillip's Academy,* 1969.

Metropolitan Museum of Art, New York, *New York Painting and Sculpture: 1940–1970,* Dec. 6, 1969–March 8, 1970. Foreword by Thomas P. F. Hoving; text by Henry Geldzahler; reprints of essays by Harold Rosenberg, Robert Rosenblum, Clement Greenberg, William Rubin, Michael Fried.

Museum of Art, Carnegie Institute, Pittsburgh, *Pittsburgh International,* Oct. 30, 1970–Jan. 10, 1971. Introduction by Leon Anthony Arkus; biographical notes by Alice Davis.

Corcoran Gallery of Art, Washington, D.C., *Depth and Presence,* May 3–30, 1971. Introduction by Stephen S. Prokopoff.

Contemporary Wing, Finch College Museum of Art, New York, *The Permanent Collection: A Selection,* May 12–June 11, 1971.

Hudson River Museum, Yonkers, *20th Century Painting and Sculpture from the New York University Collection,* Oct. 2–Nov. 14, 1971. Acknowledgments by Ruth Bowman; Foreword by Howard Conant; Introduction by Irving H. Sandler.

Neue Galerie, Kassel, *Documenta 5,* June 30–Oct. 8, 1972.

Museum of Contemporary Art, Chicago, *Modern Masters From Chicago Collections,* Sept. 8–Oct. 22, 1972. Introduction by Stephen S. Prokopoff.

New York Cultural Center, New York, *Prints for Phoenix House,* Nov. 16–Dec. 31, 1972.

Kestner-Gesellschaft, Hannover, *Henri Michaux und Joseph Cornell,* Nov. 17, 1972–Jan. 7, 1973.

National Gallery of Art, Washington, D.C., *American Art at Mid-Century, I,* Oct. 28, 1973–Jan. 6, 1974. Introduction by William C. Seitz.

Robert Elkon Gallery, New York, *Twentieth Century Masters,* Oct. 5–Nov. 7, 1974.

Pennsylvania State University, University Park, *Surrealism—A Celebration: Exhibition of Surrealist Art,* Nov. 7–23, 1974. Texts by Robert Lima and Timothy Hewes.

Rosa Esman Gallery, New York, *Small Master Works,* Nov. 23–Dec. 28, 1974.

Pace Gallery, New York, *Five Americans at Pace,* Jan. 11–Feb. 22, 1975.

Grey Art Gallery and Study Center, New York University, *Inaugural Exhibition,* Autumn 1975.

Solomon R. Guggenheim Museum, New York, *Twentieth-Century American Drawing: Three Avant-Garde Generations,* Jan. 23–March 21, 1976. Preface and acknowledgments by Thomas M. Messer; text by Diane Waldman.

Whitney Museum of American Art, New York, *200 Years of American Sculpture,* March 16–Sept. 26, 1976. Foreword by

Tom Armstrong; essays by Wayne Craven, Norman Feder, Barbara Haskell, Rosalind E. Krauss, Daniel Robbins, Marcia Tucker.

Hirschl and Adler, New York, *2nd Williams College Alumni Loan Exhibition,* April 1–24, 1976; Museum of Art, Williams College, Williamstown, May 9–June 13, 1976. Introduction by S. Lane Faison, Jr.

Austrian Institute, New York, *The World of Tilly Losch,* May 21–June 30, 1976. Organized by Louise Kerz.

Selected Screenings of Films by Cornell or from his Collection

Julien Levy Gallery, New York, *Goofy Newsreels,* Dec. 1937. The first screening of *Rose Hobart.*

Norlyst Gallery, New York, *Film Soiree* (from the film collection of Joseph Cornell; shown with special music), March 2 and March 16, 1947.

New Art School, New York, *The Subjects of the Artist: Early Films from the Unique Collection of Joseph Cornell,* Jan. 21, 1949.

The New York Public Library, Room 213, a screening of some of Cornell's films for the staff of the Picture Collection, Dec. 1957.

Contemporary Arts Museum, Houston, *Films 1948–1958,* Jan.–Feb. 1958. Organized by Jermayne MacAgy.

Film-makers Showcase, Gramercy Arts Theatre, New York, *Cornell,* Nov. 25, 1963. (Films shown: *Nymphlight, A Fable for Fountains, The Aviary, A Collage of Rose Hobart, A Century of June,* and *What Mozart Saw on Mulberry Street.*)

9 Great Jones Street, New York, a one-month showing of *Films from the Collection of Joseph Cornell,* spring of 1963 or 1964. The screenings took place in a space run by Robert Whitman and Walter de Maria.

Feigen-Palmer Gallery, Los Angeles, *Joseph Cornell Film Preview,* Jan. 28 and 29, 1964. (*Rose Hobart* and *A Fable for Fountains.*)

Contemporary Study Wing, Finch College Museum of Art, New York, *Collage Film,* shown in an exhibition, *Projected Art,* Dec. 8, 1966–Jan. 8, 1967.

Anthology Film Archives, New York (Jonas Mekas, Director), *Joseph Cornell,* Dec. 1, 17, and 18, 1970. (*Rose Hobart, Cotillion, The Children's Party, The Midnight Party, Centuries of June, Gnir Rednow, Aviary, Nymphlight, A Legend for Fountains,* and *Angel;* note slight variation in titles, appearing here as they were listed in the announcement.) The Anthology Film Archives includes Cornell's films in its repertory and shows them on a regular basis.

Solomon R. Guggenheim Museum, New York, *Rose Hobart* (shown in a film program in conjunction with the exhibition, *Max Ernst: A Retrospective*), March 8 and 9, 1975.

Anthology Film Archives, New York, *Films of Joseph Cornell. Conferences on "Working With Cornell." Cornell's Sources and Materials,* March 5–26, 1976.